BETTER PICTURE GUIDE TO
Still Life & Close-up
Photography

RotoVision

A RotoVision Book
Published and Distributed by RotoVision SA
Rue Du Bugnon 7
1299 Crans-Pres-Celigny
Switzerland

RotoVision SA, Sales & Production Office
Sheridan House, 112/116A Western Road
Hove, East Sussex BN3 1DD, UK

Tel: +44 (0) 1273 72 72 68
Fax: +44 (0) 1273 72 72 69
E-mail: sales@RotoVision.com

Distributed to the trade in the United States by:
Watson-Guptill Publications
1515 Broadway
New York, NY 10036
USA

10 9 8 7 6 5 4 3 2 1

ISBN 2-88046-426-9

Book design by Brenda Dermody
Diagrams by Roger O'Reilly

Production and separations in Singapore by ProVision Pte. Ltd.
Tel: +65 334 7720
Fax: +65 334 7721

BETTER PICTURE GUIDE TO

Still Life & Close-up
Photography

MICHAEL BUSSELLE

Contents

The World of Close-up

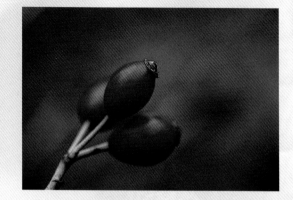

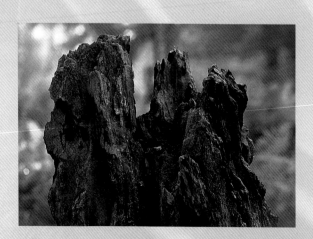

1

In normal circumstances, the majority of
photographs that you take will feature a distance
of several metres or more between the camera and subject. This reflects the
way we normally view the world: generally we find that the only occasions on
which we look at objects at a significantly closer distance are when we are
reading, writing or using a tool. But when you take a closer view of the things
around you through a camera lens, you find yourself looking at a
whole new range of picture-taking possibilities.

In the Garden

In many fields of photography - such as travel, landscape or architecture - you have to make a journey of some sort to look for suitable subjects. But with close-up photography there is the potential to produce an interesting picture almost anywhere and everywhere, and even the smallest town garden is suddenly filled with a whole variety of exciting possibilities when you begin to take a closer look at things.

Seeing

I saw these fine birds in the garden of a French cottage and was attracted by their self-important posture and the contrast between their white and gleaming plumage and the shaded barn background.

Thinking

I moved as close to them as I could without spooking them and then waited until they got used to me and had settled down. I wanted to include both birds in my shot, so I chose a viewpoint which placed them quite close together and which also set them against a fairly uncluttered area of the background.

Acting

I adjusted my zoom lens so that the birds were quite large in the frame, and I left a little space in front of the foreground bird to create a balanced composition.

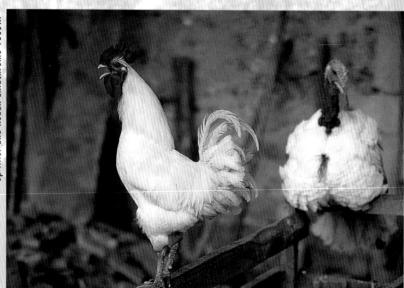

Technical Details ▶ 35mm SLR Camera with a 70-200 mm zoom lens, an 81A warm-up filter and Kodak Ektachrome 100SW.

These rose hips had been picked to make a flower arrangement indoors and had then, later, been pushed into the soil of an outdoor planter to give the garden some winter colour. Consequently, this small group of berries was quite isolated and not jumbled up among masses of foliage, as it would be in the wild. I chose a viewpoint that allowed the berries to be nicely composed in the frame and then focused on the very tip of the closest berry using a wide aperture to throw everything else well out of focus.

Technical Details
▼ 35mm SLR Camera with a 90 mm macro lens and Kodak Ektachrome 100SW.

Rule of Thumb

When you are photographing subjects like a bird or a flower your picture will have more impact if you choose a viewpoint that places an area of contrasting tone or colour behind it.

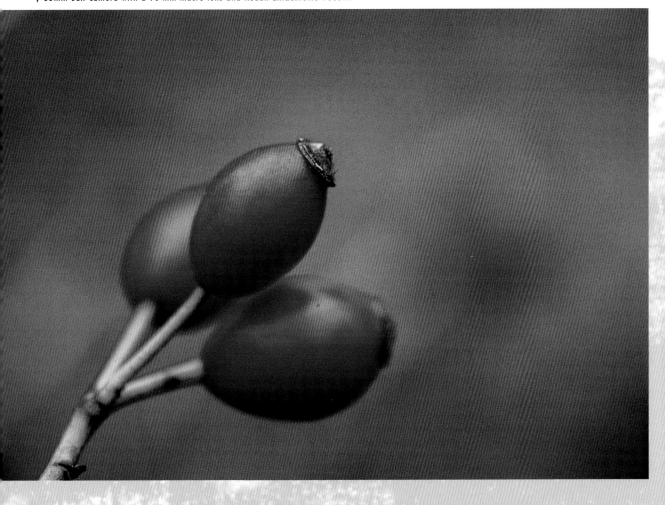

In the Garden

Seeing

I found this spider's web one morning strung across the doorway of our greenhouse. The spider was not in residence at the time but it was a nicely formed web and I decided to leave it in place, returning at intervals to check on it.

Thinking

On this occasion I found the spider well placed, right in the centre of the web and the shaded greenhouse interior provided a plain contrasting background. Unfortunately, the sun had moved around and both the web and the spider were not as clearly defined as before.

Acting

I gently sprayed the web with a plant mister - much to the spider's annoyance - and then placed a large mirror in a patch of sunlight and angled it to bounce the light onto the web. I used a macro lens in conjunction with an extension tube to obtain the largest image possible.

Technique

Many close-up shots of things like flowers and leaves can be enhanced by a little judicious spraying with a plant mister as it helps to accentuate the tactile quality of an image and adds a sparkle to the picture.

Technical Details
▼ 35mm SLR Camera with a 90 mm macro lens, an extension tube and Kodak Ektachrome 100SW.

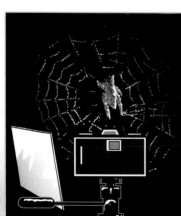

The diagram shows how a mirror was used to improve the lighting quality of this picture.

A light fall of rain combined with early morning sunlight had created this sparkling effect on the fallen leaves in my garden. I found a leaf that was in good condition and had some nicely formed droplets and, using the shadows cast from the adjacent stems of grass as an added attraction, I cropped the image tightly to emphasise these details.

I found this rather magnificent snail hidden in the grass and could not resist photographing it. But it was very inaccessible and I decided to move it onto a piece of gnarled vine stump to create a more attractive and convenient setting. I placed the wood against a plain area of background in a position that enabled me to shoot against the light on a hazy sunlit day, which has created a good degree of separation.

Technical Details
35mm SLR Camera with a 90 mm macro lens, an extension ▼ tube and Kodak Ektachrome 100SW.

Technical Details
▼ 35mm SLR Camera with a 90 mm macro lens and Fuji Velvia.

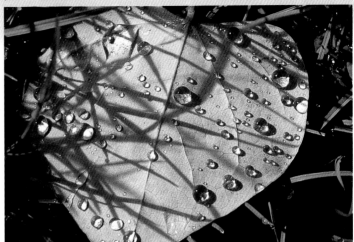

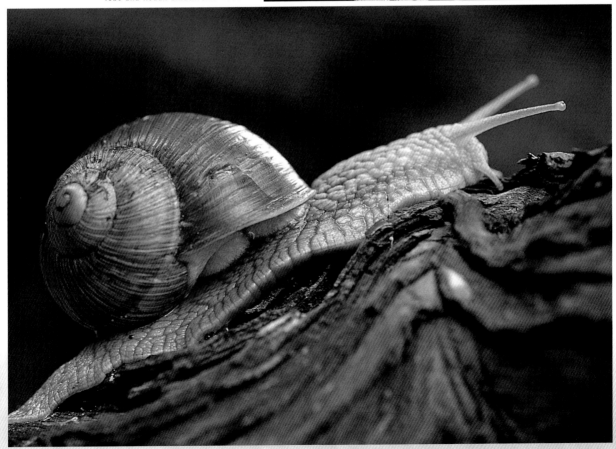

By the Seaside

The seaside offers an especially wide variety of picture possibilities to the photographer looking for close-up images. From rocks, shells, seaweed and sand patterns along the seashore, to all the things associated with harbours and fishing boats, there is a wealth of shapes, textures and colours waiting to be discovered.

Seeing

I saw this fishing net hung out to dry while visiting a fishing community on a small Maldive Island. My attention was caught initially by its unusual rich yellow colour and its contrast with the bluish shaded background.

Thinking

My first thought was to take a much wider view of the scene using a more distant viewpoint. I realised, however, that if I did so, I would lose much of the textural effect of the net and I also thought that including more of the scene would lessen the impact of the bold colour.

Acting

I decided to move much closer to my subject and then used the longer setting on my zoom lens to restrict the image area to the most interesting section of the fishing net. My viewpoint also allowed me to include the small basket in the bottom right-hand corner.

Technical Details ►
35mm SLR Camera with a 35-70 mm zoom lens and Kodak Ektachrome 64.

Technical Details
▼ 35mm SLR Camera with a 28 mm lens and Kodak Ektachrome 64.

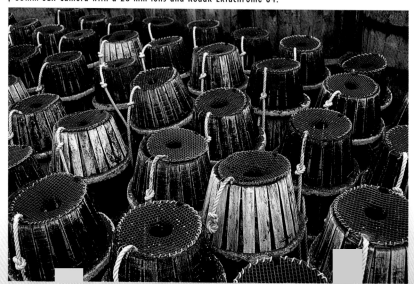

These lobster pots were spread out beside a beach in Picardy, France. They appealed to me because they were almost neutral in colour and I liked also the pattern that their repeated shapes created. I used a wide-angle lens and took up a very close viewpoint that allowed me to shoot slightly down on them, thus creating an interesting perspective effect.

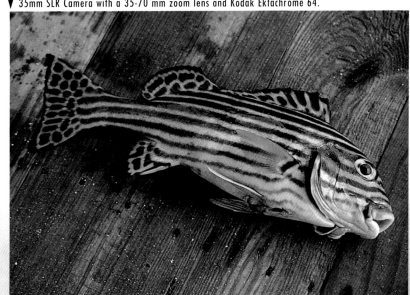

This picture was taken during a trip to the Maldive Islands. My friend Terry had caught this fine specimen with a spear gun and was justly proud. It's a very straightforward shot: I framed quite tightly on the dramatically striped fish and this, seen against the weathered, wooden-deck background, produced a bold effect. The soft lighting was provided by hazy sunlight.

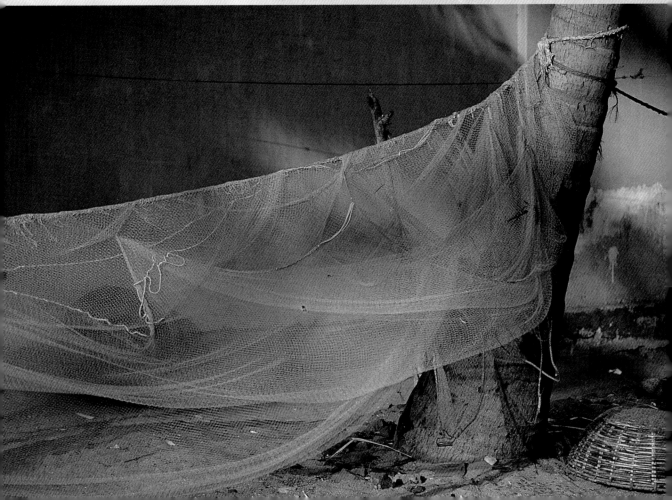

By the Seaside

The diagram shows how including more of the scene in this picture would have resulted in a weaker picture.

I saw this brightly-painted fishing boat in a small Spanish harbour and was attracted by the quality of the lighting in the scene and the strong contrast between the boat and the darker shaded tone in the background. My first thought was to shoot the boat in its entirety, using a fairly distant viewpoint, but when I viewed the scene through my camera I realised that the ropes had an even more striking quality about them than the boat. The solution was to shoot from much closer in, framing the image so that the ropes became the dominant element of the picture.

Technical Details
35mm SLR Camera with a 70-210 mm lens and Kodak Ektachrome 64.

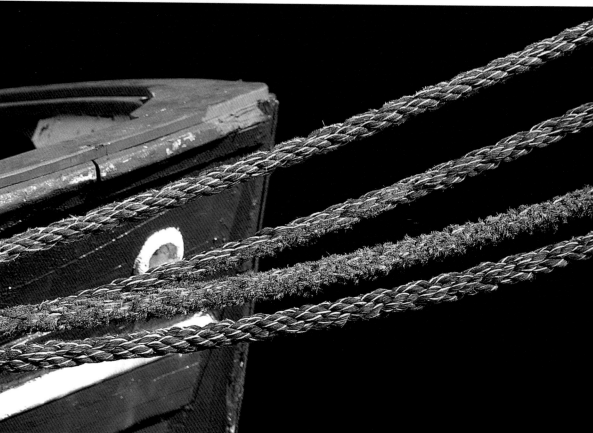

Seeing

I found this picture on a small beach in North Devon. The sand here is quite light in tone but at low tide a small stream runs across the beach and carries a much darker, silty soil, which is deposited on the sand. I became fascinated by the patterns this created and spent some time looking for pictures.

Thinking

Since the subject is almost monochromatic, I wanted to find areas where the patterns were strongly defined and to look for viewpoints which accentuated them. I found that this meant shooting from almost directly above.

Acting

I placed my camera less than a metre away from the sand and used a wide-angle lens to enable a larger expanse of the pattern to be included and to exaggerate the effect of perspective. I found that a polarising filter had a very striking effect, increasing the contrast between the light sand and the dark silty soil and making the pattern even stronger. I used a small aperture to ensure the image was sharp from front to back.

Technical Details

35mm SLR Camera with a 17-35 mm zoom lens, a polarising filter and Fuji Velvia.

Forests & Meadows

Trees, leaves, flowers and grasses are all subjects which can provide powerful images when the camera is placed close enough to them to reveal the finer detail of their structure and form. The pictorial potential of subjects like these is further enhanced by the changing of the seasons; each phase in the year can reveal different possibilities, from the rich colours of autumn foliage through to the vivid hues of summer and the textural qualities which frost and rain can bring.

Seeing

I woke one autumn morning to discover that a hard, hoarfrost had descended on the countryside and I decided to visit a wood near my home to explore the possibilities this might offer. I found that the recently fallen leaves had been given this beautiful crystalline coating.

Thinking

I found this particular leaf which was almost perfectly shaped and which, quite naturally, was nicely placed among those surrounding it. As I began to set up my shot I realised that the sun had climbed high enough to begin to reach this small area of woodland and that the frost would soon melt.

Acting

To allow me to emphasise its shape, I used a viewpoint that looked almost immediately down on the leaf, and then I framed the image so that the leaf almost filled the frame. Tilting the camera slightly to place the leaf along a diagonal line, I waited until the sun reached this particular spot before shooting.

Rule of Thumb

With very close-up images the depth-of-field is so shallow that it's important to choose viewpoints which ensure the most important aspects of the subject are on a similar plane, and thus square on to the camera, if you wish to ensure they are recorded sharply.

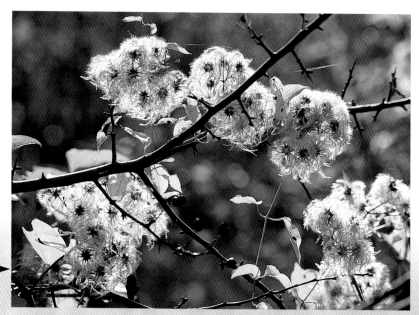

I used a long-focus lens to isolate a small section of this old man's beard and used a wide aperture to throw the background details out of focus and to prevent them from becoming too distracting.

Technical Details ▶
Medium Format SLR Camera with a 105-210 mm zoom lens and Fuji Velvia.

Technical Details
▼ Medium Format SLR Camera with a 55-110 mm zoom lens, an extension tube and Fuji Velvia.

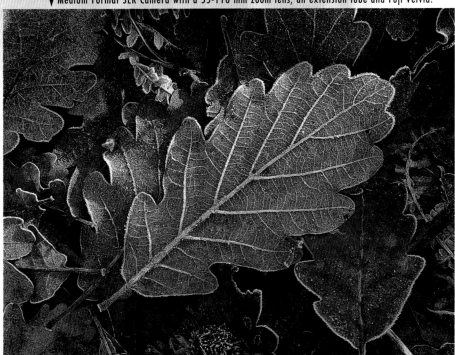

These bracken leaves were photographed in the same wood a few weeks earlier and I found their glorious golden colour irresistible. I chose a viewpoint that placed the main fronds against a relatively uncluttered area of background and framed the shot fairly tightly to make them the main focus of attention.

Technical Details ►
Medium Format SLR Camera with a 55-110 mm zoom lens, 81B warm-up and polarising filters with Fuji Velvia.

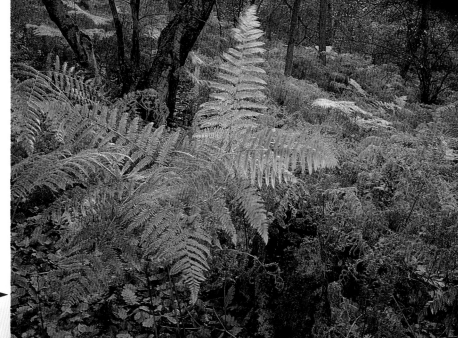

Forests & Meadows

Rule of Thumb

It's a mistaken belief that bright sunlight is always best for colour photographs. This is not always so - especially with close-ups - as the dense shadows and bright highlights which sunlight creates will diminish the effect of colour. The softer light of an overcast or hazy day will usually produce more pleasing results.

Seeing

I found this lovely field of lavender while travelling through Provence one summer and stopped to explore the possibilities. The lavender was almost at its peak and its colour was consequently very strong.

Thinking

At first I began to look for quite wide views of the scene using a more distant viewpoint which allowed me to look along the planted rows. But my pictures lacked a point of interest: I needed a tree, a hut or something in the middle distance and there was nothing. It was then that I took notice of the grasses and realised that, with a much closer viewpoint, they could do the job for me and create an effective contrast to the lavender.

Acting

I chose a viewpoint quite close to the most attractive clump of grass, which was high enough to let me look slightly down on the lavender. Using a wide-angle lens to include more distant details and to heighten the sense of depth and distance, I framed the image so the main grasses were in the centre of the viewfinder. Then I tilted the camera up slightly to place them nearer the bottom of the picture. I used a polarising filter to increase the colour saturation and set a small aperture to ensure I had adequate depth of field.

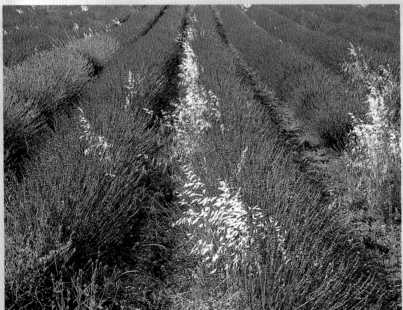

Technical Details
Medium Format SLR Camera with a 55-110 mm zoom lens, 81A warm-up and polarising filters with Fuji Velvia.

Technical Details
▼ Medium Format SLR Camera with a 105-210 mm zoom lens,
81B warm-up and polarising filters with Fuji Velvia.

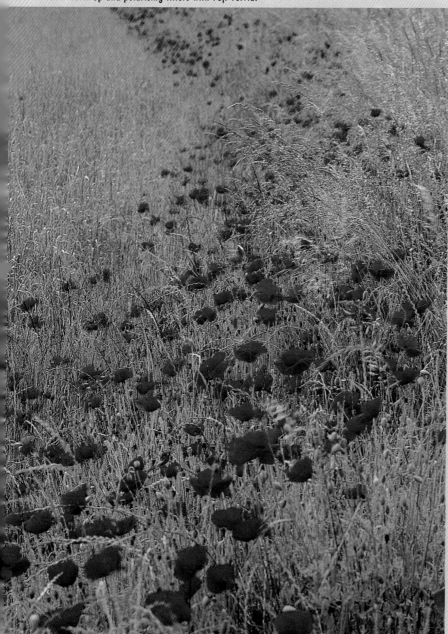

This cluster of poppies was on the edge of a field of unripened wheat and I was struck by the bold contrast between the deep red blooms and very intense green field. Instead of shooting from a close viewpoint I used a long-focus lens from a greater distance, which compressed the perspective and made the poppies appear to be growing more densely. It also enabled me to frame the image tightly enough to exclude the horizon and sky which, had they been included, would have added a third colour to the picture, diminishing its impact.

This diagram shows that by including more of the scene the impact of the picture would have been lessened.

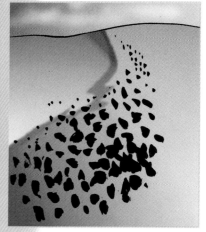

Forests & Meadows

Technical Details
▼ Medium Format SLR Camera with a 105-210 mm zoom lens, an extension tube, an 81A warm-up filter and Fuji Velvia.

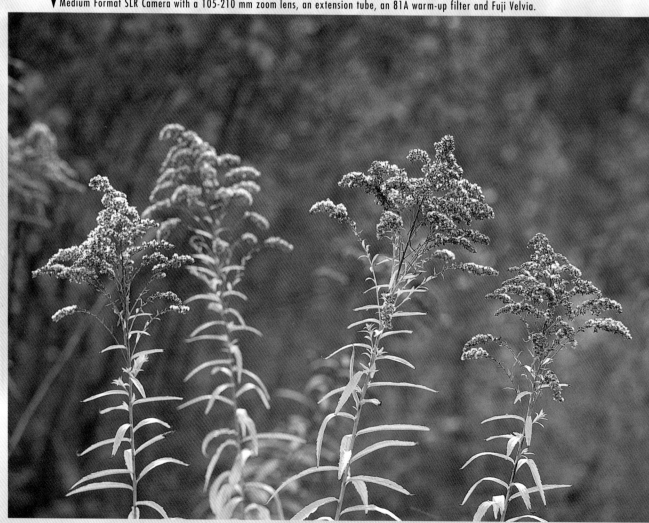

Seeing

I spotted this clump of dying grasses while walking on the downs one autumn. I was attracted initially by the soft backlighting which a hazy sun was providing: this was giving the grasses a fluffy, feathery quality and, thinking in terms of a wide view, I began looking for a viewpoint from where I could isolate a section of them.

Thinking

As I searched I became aware of the foliage some distance behind the grasses, which was a clump of shrubs with autumnal leaves and berries. On looking through the viewfinder of my SLR I found that, when thrown out of focus, this background detail formed a very pleasing mixture of soft colours, which provided a sympathetic foil to the almost white grasses.

Acting

I decided to use a much closer viewpoint in conjunction with a long-focus lens. This enabled me to isolate a small clump of the grasses and, at the same time, ensured that the background details were softened to the point where they wouldn't be distracting. I focused on the closest grass head and used a wide aperture. Though the depth of field I used was narrow enough for some of the other grass heads in the frame to be slightly unsharp I quite liked the effect, and closing down the aperture would, in any case, have risked bringing in too much of the background detail.

While taking photographs in a French village I saw a group of mature plane trees, which had particularly attractive bark. I fitted a long-focus lens and an extension tube to my camera and began to look for the most striking area of pattern through the camera. As might be expected, there were several options and I took a number of pictures that worked quite well, some of which involved tighter framing on the image than here. I liked this one best though, because the slightly wider view revealed a pleasing balance between the orange, green and grey flecks in the bark and helped to add interest to the pattern.

Technical Details ▶
Medium Format SLR Camera with a 105-210 mm zoom lens, an extension tube, an 81A warm-up filter and Fuji Velvia.

Urban Details

While natural forms have a special appeal to those interested in close-up photography, man-made objects also have a great deal to offer and there can be few better hunting grounds for such images than a town or city street. While the forms, colours and textures created by nature undoubtedly have an appealing quality, those found among streets and buildings can provide a strong graphic element in close-up images, which can help to produce strikingly different pictures.

Seeing

I saw this poster-covered wall while walking through London's Soho and was immediately attracted by the rather grubby, tattered state of the bills. I also liked the fact that, to me anyway, the text was illegible, which produced a rather abstract quality.

Thinking

My first thought was to move in much closer and to focus on the very tattered panel in the top right sector of the image. But this would have been such an abstract approach that I doubt whether the subject would have been recognisable as a poster at all.

Acting

Because I wanted the image to have at least some point of reference, I took a slightly more distant viewpoint to include a greater expanse of the wall and I framed the image so that it was divided into almost equal rectangular segments. I also included the small uncovered area in the bottom left to balance the composition.

Technical Details
35mm SLR Camera with a 50 mm lens and Kodak Ektachrome 64.

I saw these graffiti-covered panels on a French bus shelter and loved the mixture of brown and blue-grey. Subjects like this, which have a very limited colour range, often work well when combined with a bold shape or texture. I framed the image so that the whole of the word 'Enfer' was included, while just a small amount of the lettering in the opposite corner was included to balance the composition.

▲ Technical Details
35mm SLR Camera with a 24-85 mm lens and Kodak Ektachrome 100SW.

Rule of Thumb

When photographing rectangular objects, or those with dominant parallel lines, it is invariably most effective to use a viewpoint which places the camera square on to the subject. Even a slight amount of unwanted perspective can disturb the symmetry of such images and consequently will diminish their impact.

Urban Details

<div style="border:1px solid;">

Rule of Thumb

A long-focus lens can be a very useful accessory for close-up photography as it enables you to work at a more comfortable or convenient distance from very small objects. It also makes it possible to take close-up pictures of more distant objects.

</div>

I find American cars quite fascinating and I felt I had to shoot this shiny Lincoln with its colourful numberplate. I opted for a viewpoint that gave me a full frontal view of the grill, which was beautifully lit by light reflected from the road. I framed the shot so that the grill and numberplate almost filled the frame but used the headlights and part of the bonnet as a border.

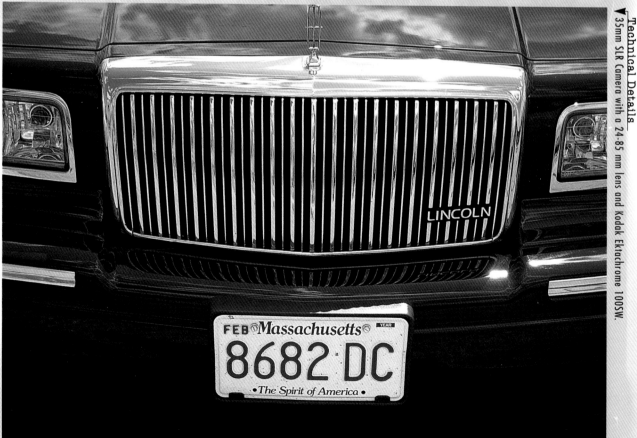

Technical Details 35mm SLR Camera with a 24-85 mm lens and Kodak Ektachrome 100SW.

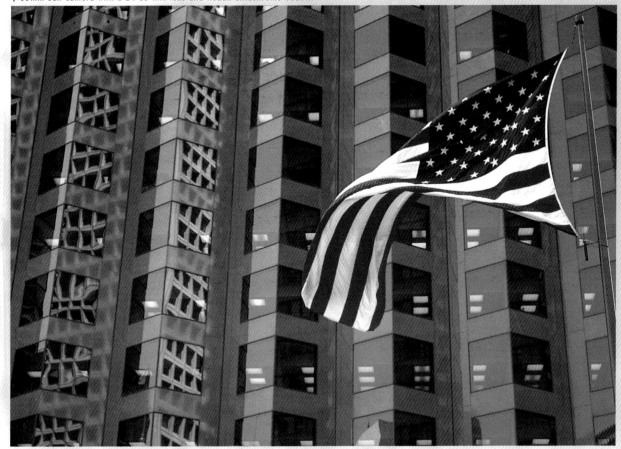

Seeing

This shot was taken in San Francisco during my first visit to the US and, like many others I imagine, I was drawn to the graphic possibilities of the ubiquitous high-rise buildings.

Thinking

I felt sure there would be some potential in combining these two icons and on my walks through the city streets kept my eyes open to a likely situation. This picture appealed to me because the distant building was in the shade and, consequently, had a bluish cast that made the more brightly lit flag stand out very strongly.

Acting

I took up a viewpoint that enabled me to place the flag against a section of the building where there were no reflections and I initially framed the shot so that this alone formed the background. But on exploring the subject further I decided that I preferred a slightly wider view as this allowed me to place the flag in one half of the image with the window reflections in the other section, where they could act as a balance to the flag.

Around the Home

Interesting close-up photographs can often be made without even having to leave the house. There are numerous everyday objects around the home which, when subjected to a closer scrutiny, can reveal surprisingly effective pictorial qualities. On wet or wintry days it can pay to have a closer look at your possessions as you're quite likely to discover a wealth of highly photogenic subjects you had previously been unaware of.

Seeing

I have a small collection of knives made in a small French town called Laguiole. They've been made there for centuries and, being made of stag's horn and brass, I find them quite lovely objects with a very tactile quality. Far too nice to use in fact!

Thinking

I set the shot up on a table in a room with a well-lit window. I'd intended to include the entire knife in my picture but being long and thin, it would not have worked in a composition without some other elements being included and so I decided to shoot a much closer view of just one section of it.

Acting

With the knife held upright in a small clamp, I used a macro lens to isolate this very sculpted section where I thought the turned brass, steel blade, corkscrew and polished horn created a quite tactile quality as well as forming nice shapes. I placed a piece of textured writing paper behind the knife to act as a background and positioned a small white reflector opposite the window to throw light back into the shadows.

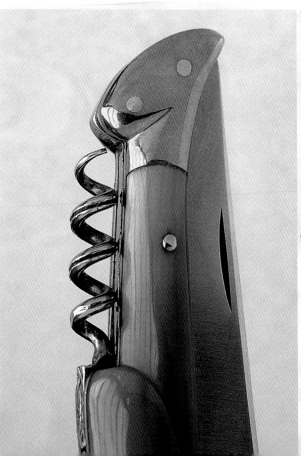

Technical Details
▼ 35mm SLR Camera with a 90 mm macro lens and Fuji Velvia.

The set up for this shot is shown here together with my homemade clamp for supporting small items.

Technical Details
▼ 35mm SLR Camera with a 90 mm macro lens and Fuji Velvia.

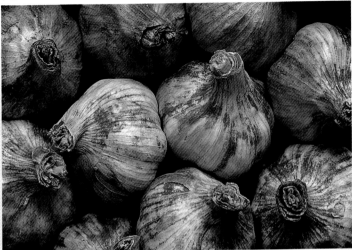

I'd just bought some garlic, which was so fresh that it had retained much of its natural colour, which is largely lost when it's dried. The bulbs were in a small basket and I just placed it on the floor and shot almost directly down using window light.

I framed this image really tightly so that only the cat's face and whiskers were included, which emphasised her good looks and added impact to the image.

▲ **Technical Details**
35mm SLR Camera with a 70-300 mm zoom lens and Fuji Velvia.

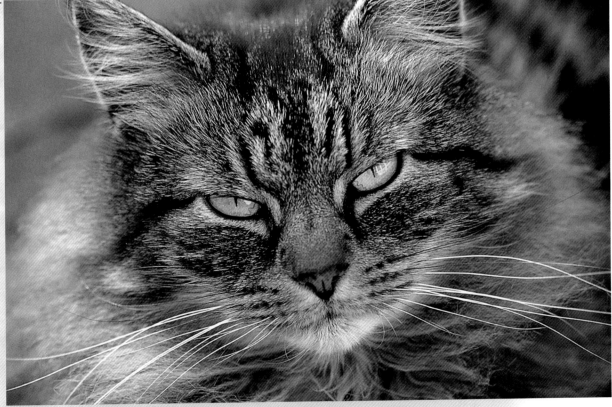

The Abstract Approach

One of the drawbacks of photography as a medium is that it's so realistic it can be a restriction for those who want to take photographs of a more expressive and pictorial nature. Of all the techniques that can be used to make a photographic image less factual the simplest is to use a close-up image to show the subject out of context. This will make it less immediately recognisable and consequently more abstract.

This is quite a simple set-up, a glass fish tank filled with water. I set a large piece of white paper behind it and aimed a flash at this to create a reflected light source. With my camera set up and focused on a predetermined area, I then used an eyedropper to introduce small blobs of watercolour dyes, which I allowed to sink slowly into the required position before shooting.

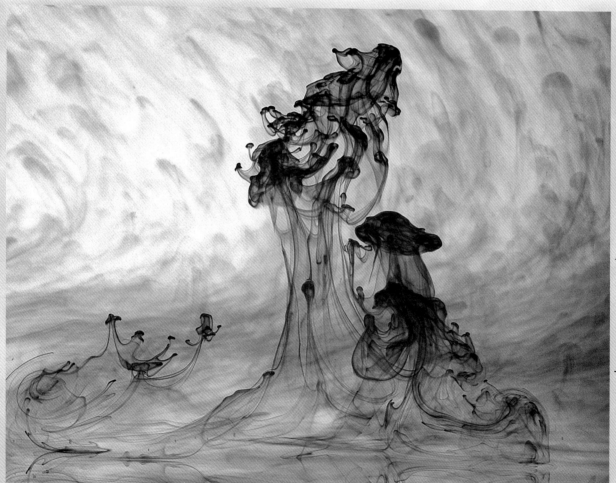

Technical Details
Medium Format SLR Camera with a 55-110 mm zoom lens, an extension tube and Fuji Velvia.

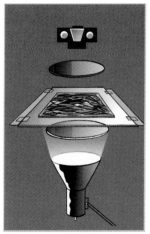

The set-up for the crystal photograph is shown here.

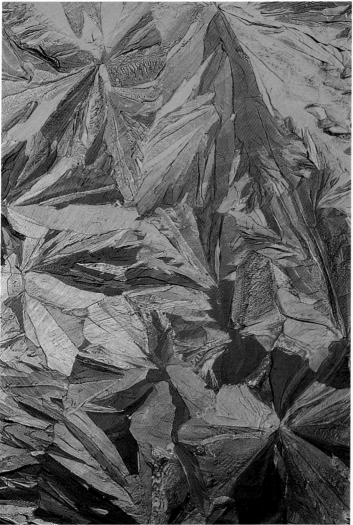

Seeing

This is an accidental variation on the technique where polarised light is used to illuminate stressed plastic or crystals which are then photographed through a polarising filter to create rainbow colours.

Thinking

I made up a saturated solution of tartaric acid, which was spread on the plastic cover of a CD case, because I didn't have a convenient piece of glass to hand. This was then allowed to dry to form crystals.

Acting

When I viewed it through the camera I was astonished to discover that there had been an apparent interaction between the crystals and the plastic and a much greater, and more dramatic, range of colours had been created. I then made some more crystals on a glass slide mount and placed this onto a clean CD cover and found that, by changing the relative positions of the crystals, the plastic, the light source and the polariser on the camera I could produce an almost limitless range of effects.

Technical Details
35mm SLR Camera with a 90 mm macro lens, two extension tubes, and Fuji Velvia.

The Abstract Approach

Seeing

I found this **brightly-coloured lichen** growing on some rocks along a Scottish seashore and was struck by the bold contrast between it and the **steely grey** stone.

Thinking

The important thing with shots like this is to introduce an element of **design** and **composition** into the image in order to give it a pictorial quality and to create a degree of impact.

Acting

I fitted my **macro lens** to the camera and then, using a **tripod**, I began a careful exploration of the most interesting section of the rock using a viewpoint that limited the image area to about 400 x 600 cms. I found this particular spot to be the most appealing because the lichen was distributed in an orderly way and the rock had some **bold markings.** I found that, by tilting my camera to one side, the markings created a noticeable diagonal line, which I felt produced a more **dynamic composition.**

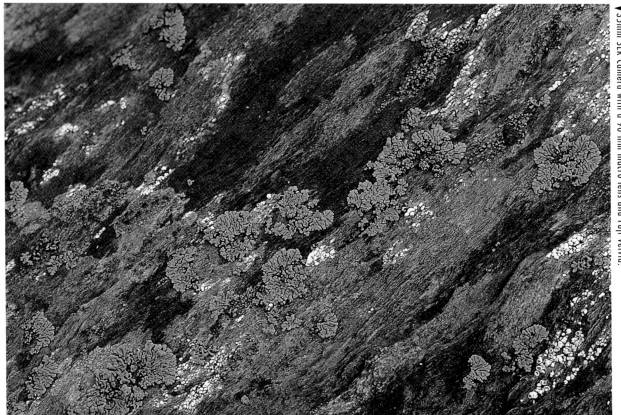

Technical Details
35mm SLR Camera with a 90 mm macro lens and Fuji Velvia.

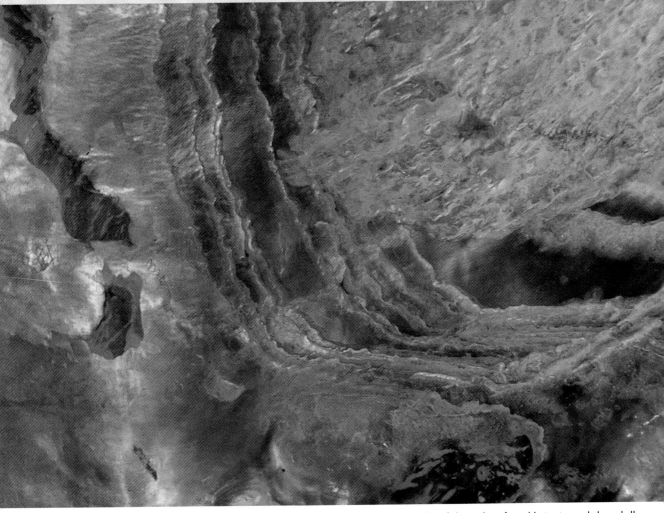

This is a very simple close-up shot of the mother-of-pearl lining in an abalone shell. I moistened the shell to accentuate the colours, and then shot this picture indoors by a window, using a macro lens and an extension tube to focus on a very small area. I found that by slightly tilting the shell in different directions I could obtain a wide range of effects.

Technique

When shooting extreme close-ups with a tripod-mounted SLR camera there is a greatly increased risk of blur due to vibration, even when a remote control or cable release is used. This can be completely eliminated if your camera has a mirror-lock facility; operate this a few seconds prior to shooting and you'll do away with the vibration that is caused when the mirror flips up at the actual moment of exposure.

Photographing Plants

Plants and flowers are probably the most popular
subjects for close-up photography because they possess
a huge variety of shapes, colours, textures and patterns - all the elements which can be
harnessed to produce bold and striking images. It's important not to allow your pictures to be
overwhelmed by colour and detail and to look for ways in which the most
important elements can be isolated from their surroundings.

Seeing

These two images, taken on the same occasion, feature early spring
crocuses growing in my garden. They formed a quite impressive
carpet of colour, which extended over a fairly large area. I
looked for small clumps of flowers, which I could isolate as I
felt that to include too wide an area would result in a confusing
image with little real impact.

Thinking

The blooms had only recently formed and were facing mainly upwards
to the sky and I thought that a viewpoint above them would
be the most effective. I particularly wanted to show the intense
colour at the edge of the petals and the way it faded to almost
white in the centre of the flower.

Acting

This small clump of blooms was the most tidy, with no
dead flowers to ruin the scene. With my macro
lens fitted, I set my camera about 300cms away
and from almost immediately above: the result was
this picture which conveys the feeling of everything
spreading out. I framed the image so that most of the
blooms were included while most of the distracting
elements around the plant were excluded. I
then looked for a single bloom as I felt this too could
make a pleasing picture but I needed to move one or
two distracting details away so that the
flower was completely isolated.

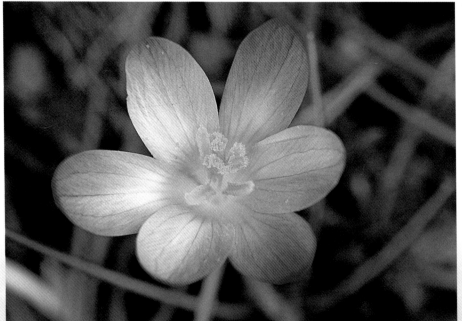

Technical Details
Medium Format SLR Camera with a 28-70 mm zoom lens and Fuji Velvia.

Technical Details

▼ Medium Format SLR Camera with a 55-110 mm zoom lens, an extension tube and Fuji Velvia.

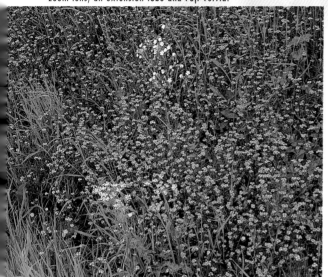

I found this clump of wild flowers in a hedgerow in Burgundy, France, early one summer and was very taken by the combination of the intense blue flowers and the green grass. I framed the picture to include the small area of yellow blooms in the left corner of the image and to place the few white flowers more or less in the centre.

Rule of Thumb

When photographing plants in situ don't be afraid to do a little 'gardening.' This can include tidying up the surroundings, removing dead blooms, twigs or leaves, tying back unwanted grass or branches and, if necessary, altering the angle of your subject to give you the best aspect (flower-arranging wires can be very useful for this).

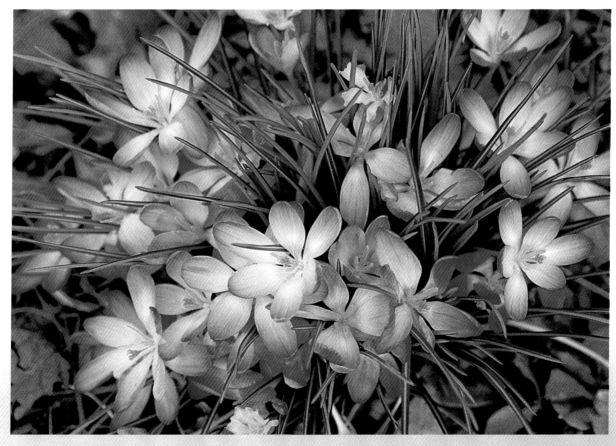

Photographing Plants

Rule of Thumb

Remember that using a more distant viewpoint with a long-focus lens will minimise the effect of perspective while a close viewpoint combined with a wide-angle lens will exaggerate it and increase the feeling of depth and distance in the image.

I saw this field of artichokes as I travelled through Brittany, France, one summer. The sun was behind them and the light, which was glancing off their spiky heads and leaves, attracted me. I used a wide-angle lens to allow me to take up a close viewpoint and to exaggerate the perspective and then I set my tripod high so that I could shoot slightly down on them. This has helped to create a feeling of depth and distance in the image. I used a small aperture to ensure there was enough depth of field and framed the image to exclude the horizon and sky, which has effectively restricted the image to a single colour, enhancing the quality of pattern and texture.

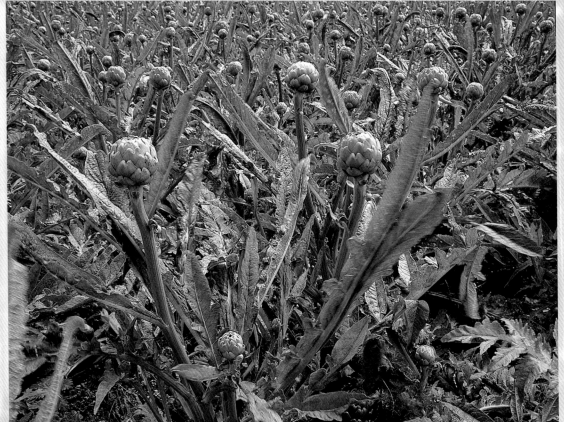

Technical Details
Medium Format SLR Camera with a 55-110 mm zoom lens and Fuji Velvia.

Technical Details

▼ 35mm SLR Camera with a 90 mm macro lens, an extension tube and Fuji Velvia.

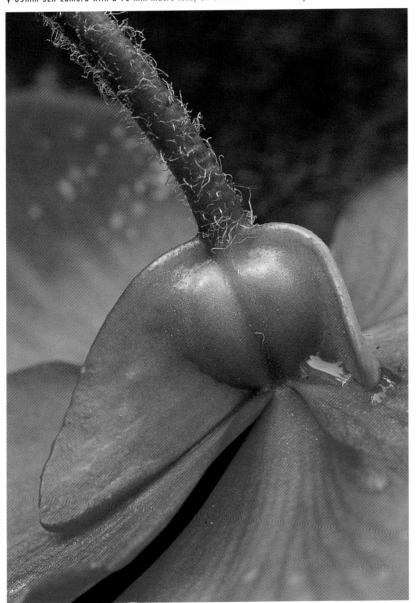

Seeing

I was taking photographs of some begonias in my garden when I noticed the detail behind the flower head. The shape of the stem and of the calyx behind the petals attracted me; there was almost an erotic quality about this part of the plant.

Thinking

I wanted to make this detail as visible as possible and I also felt it would produce a more interesting image if I could give the image a rather abstract quality. For this reason I decided to shoot from a very close viewpoint so that I could frame the image very tightly while focusing only on this small area of just a few square centimetres.

Acting

I fitted my macro lens together with an extension tube, which allowed me to focus at a distance which gave me a larger than life-size image. I used a very small aperture to ensure there was adequate depth of field and erected a screen just out of view to prevent wind movement, since I needed to use quite a slow shutter speed.

Photographing Plants

Technical Details
▼ 35mm SLR Camera with a 90 mm macro lens and Fuji Velvia.

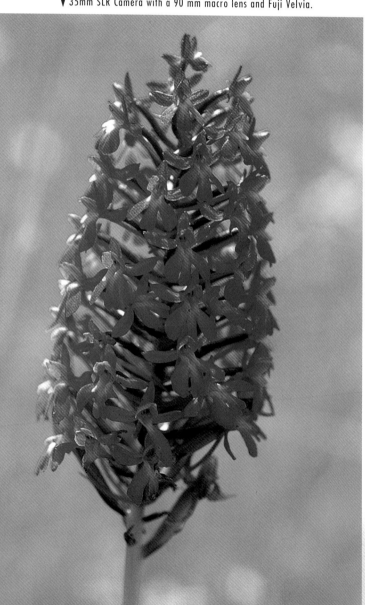

Seeing

As I drove through a quiet part of the Dordogne, France, I spotted a meadow that was carpeted with these **purple orchids**. It was quite a stunning sight as they were growing quite densely and covered a large area.

Thinking

I wanted to try and photograph them in a way that showed this impressive display and tried a variety of combinations of viewpoint and lens. I seemed unable, however, to find a way to make an interesting image using a **wider view**, largely because the effect of the colour was **lessened** by the inclusion of other details.

Acting

Ultimately I decided that the blooms would make a far more interesting and effective picture if I simply focused on a **single plant**. As I had plenty of flowers to choose from, I looked around to find one that was in good condition and was well separated from its neighbours. I chose a viewpoint which gave me an almost worm's-eye view of the flower, and which also placed a plain area of grass behind it as a background. I selected an **aperture** that was small enough to ensure the bloom was **sharp** all over but which was wide enough to throw the background details out of focus.

There is an inclination when photographing a single bloom to want to include all of it in the picture but in this case I felt that the very central section of this Camellia bloom was so appealing that I would produce a stronger image by using a much closer viewpoint. This has emphasised the spiral effect of the petals, which has been further enhanced by restricting the image to a single colour.

Technical Details
▼ 35mm SLR Camera with a 90 mm macro lens and Fuji Velvia.

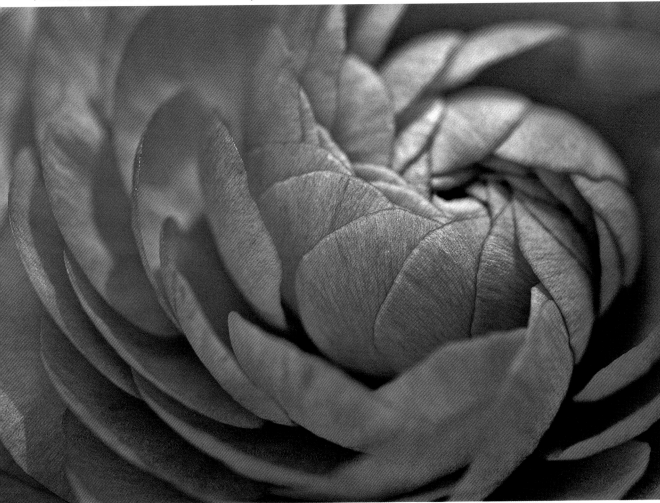

Wood, Stone & Water

These three natural elements form the basic structure of our planet and give the landscape its shape and form. Because of this, they can be easily overlooked in terms of their individual potential as subjects for close-up photography. But they have a great deal to offer the observant photographer and what they may lack in variety of colour is compensated for by the rich range of textures, shapes and forms which can be exploited to produce strong and interesting images.

Seeing

While travelling through the Medoc vineyards in South West France I came across this stack of newly made wooden stakes, which were to be used to support the vines. They formed a striking pattern, which I felt could produce a strong picture.

I saw these reflections in a Venetian canal, as light from the blue sky mingled in the rippled surface of the water with the light bouncing from an ochre-coloured canal-side facade. I used a long-focus lens to isolate a small section of the water and framed the image to include the most interesting area of the reflections.

▲ Technical Details
Medium Format SLR Camera with a 105-210 mm zoom lens, an 81A warm-up filter and Fuji Velvia.

Thinking

I felt that the effect of the pattern would be heightened if I restricted the image to a single colour and decided to use a long-focus lens and a close viewpoint to isolate a small section of the pile. At the same time this allowed me to exclude any of the surrounding details.

Acting

I spent some time moving my viewpoint a little from side to side and up and down as well as adjusting my long-focus zoom. Finally I found a section where there was a good balance between the shapes created by the pointed and sawn ends of the stakes.

There is a natural tendency when viewing
through a camera's viewfinder to use it rather
like a gun sight, as an aid to aiming. This often
results in only the central part of the picture
being seen and this in turn can lead to
distracting and unwanted details being
included in the image. It is much better to
check the edges of the viewfinder first to
decide what should be included or excluded.

▶ **Technical Details**
35mm SLR Camera with a 70-210 mm zoom lens, 81B
warm-up and polarising filters with Kodak Ektachrome 64.

Technical Details
▼ 35mm SLR Camera with a 70-210 mm zoom lens, an
81A warm-up filter and Kodak Ektachrome 64.

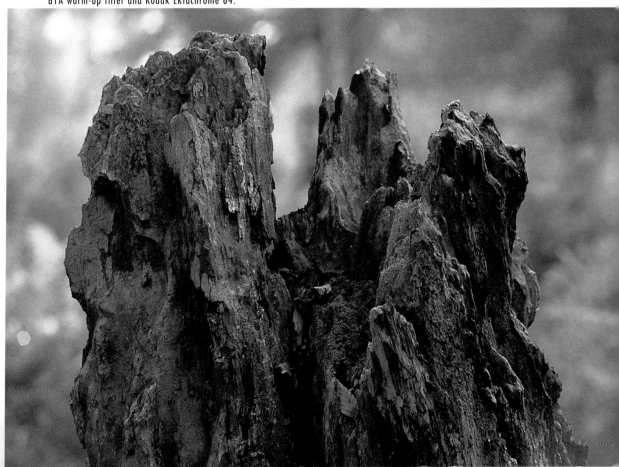

I used a long-focus lens and a wide aperture so that the autumnal trees
behind this weathered tree stump would record as a soft homogeneous blur.

Technical Details
▼ 35mm SLR Camera with a 90 mm macro lens and Fuji Velvia.

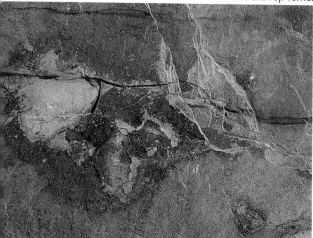

Seeing

This **waterfall** is in the Yorkshire Dales, UK, and I visited it in the winter when there was a good flow of water. I was attracted by the fact that the shaded foreground had a bluish quality and the warm afternoon sunlight was being reflected from a cliff face behind to create these **orange-tinted highlights**.

Thinking

I felt that this contrast would be accentuated by using a **close viewpoint** and by limiting the image area to where the colours were strongest by using a **long-focus lens**.

Acting

I chose a viewpoint which placed the rocks and white water in the close foreground with the warm reflections immediately behind. I used a small aperture with a **slow shutter speed** - about two seconds - to record the water as a soft smoke-like blur.

This is a very straightforward shot of a small section of rock on the seashore. I used a close viewpoint and a macro lens to isolate this attractive combination of cracks, colours and textures, framing the image carefully so that I could create a balanced composition.

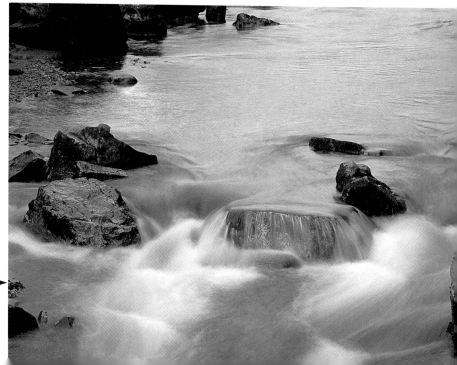

Technical Details ▶
Medium Format SLR Camera
with a 105-210 mm zoom lens
and Fuji Velvia.

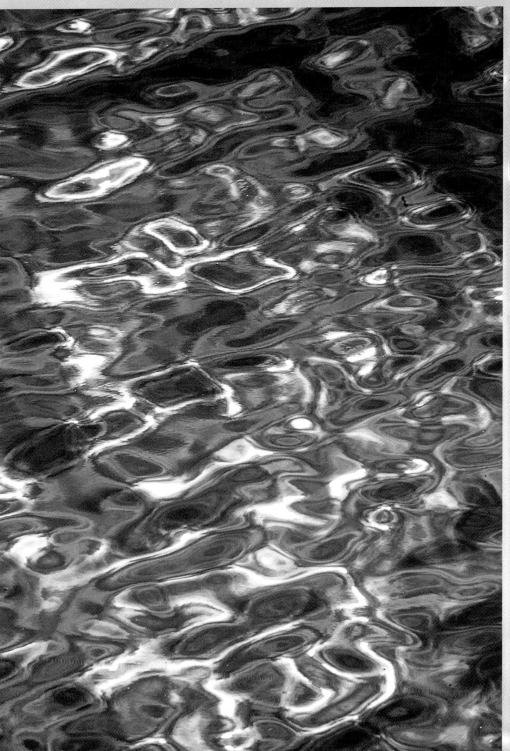

Technical Details
35mm SLR Camera with a 70-210 mm zoom lens,
an 81A warm-up filter and Kodak Ektachrome 64.

The reflections in this
rippled water had
created an almost
quicksilver quality
and a pattern that
greatly appealed to
me, and the almost
monochromatic nature
of the image seemed
to enhance this. I
looked for a suitable
viewpoint and then
used a long-focus lens
to frame a small area
of the water. The
upright format I was
using allowed the
reflections to be used
in a balanced and
cohesive way.

Composition & Light

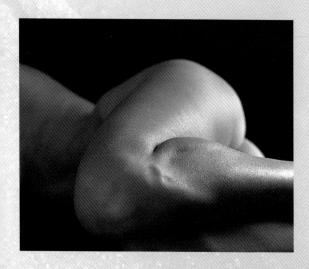

2

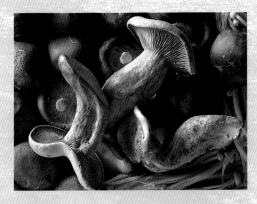

The quality and direction of the light is one of the most important factors in the success of all photographs. Lighting is responsible for revealing the shape and form of a subject and enhancing qualities such as texture and colour. Whether you are shooting close-ups of flowers in the wild or still life set-ups using studio lighting, it is vital to be aware of the relationship between light and the subject. Composition is simply the art of organising the various elements of a subject within the borders of the frame to the most telling effect.

Light & Form

Form is the quality which enables a two dimensional photograph to create the impression of three dimensions. It is the element which gives an image a sense of solidity and depth; the position of the light source in relation to the subject, and the degree to which it is diffused, will determine how effective this element of an image will be.

Seeing

During this studio session with a model I was experimenting with body positions and lighting, with a view to taking a series of close-up, semi-abstract images in which the model's body would take on something of the aspects of a landscape. This particular pose seemed to work very well, as her tightly folded limbs had created a very pronounced sense of form and depth.

Thinking

I felt that I could emphasise her pose to the greatest effect by framing very tightly and then restricting the image to just flesh tones by using a dark background. This would focus all the attention on the tonal range of the image, which in turn would enhance the impression of form and solidity.

Acting

I decided to use a large, diffused light source, a soft box, slightly behind and to the right-hand side of the model. This created the highlight on her hip and thigh, and then I used a white reflector placed close to the camera on the left hand side to throw enough light back into the shadows to make the transition of tone from highlight to shadow more gradual.

Technical Details
▼ 35mm SLR Camera with a 70-300 mm zoom lens, an 81B warm-up filter and Fuji Velvia.

The soft light of a hazy day was perfect for this shot of the stone carvings above the portal of the Abbey of Conques in the Lot region of France. It allowed me to capture an image with a fairly subtle transition from highlight to shadow within the quite small details of the sculptures, creating an effective impression of solidity and depth. Bright sunlight would have produced too much contrast, restricting the range of tones and creating a less pleasing effect.

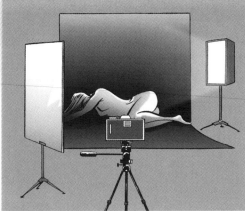

Rule of Thumb

A good way of judging the tonal range of a subject, and its contrast, is to look at it through half-closed eyes. Alternatively, if your camera features a stop down facility, you can view through the viewfinder with the lens set to a small aperture.

The lighting set up for this picture is shown here.

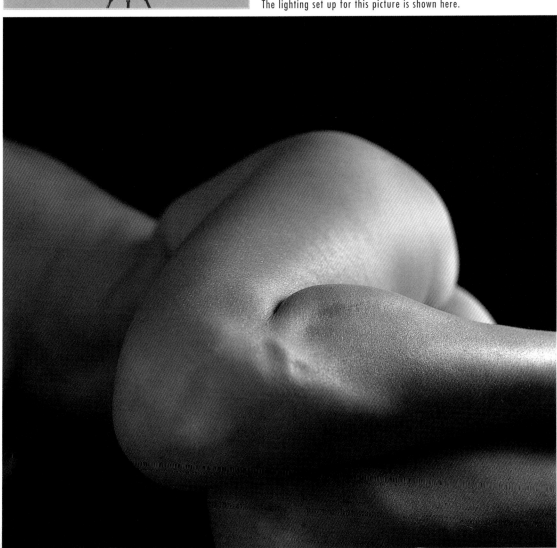

▼ Technical Details
Medium Format SLR Camera with a 200 mm lens and Kodak Ektachrome 64.

Light & Form

Seeing

I saw this beautiful brass door knocker while walking in a Spanish street. It appealed to me initially because of its rich colour and the contrast between it and the dark brown door.

Thinking

As I looked for a good viewpoint I became aware that its beautifully sculpted form held even more appeal for me than its colour and I began to look for ways in which this could be accentuated.

Acting

There was little opportunity to control the lighting and contrast of the subject other than by the choice of viewpoint and I moved from side to side of the knocker and up and down a little until I arrived at this effect. The light from the sky has created a good range of tones on the shiny metal but with highlights that are not too bright.

Technical Details
▼ Medium Format SLR Camera with a 55-110 mm zoom lens and Fuji Velvia.

This still life shot of crystallised fruits has significantly higher contrast than the previous image and the transition of tone is more abrupt. This is partly due to the strong highlights on the shiny fruit but there is detail in all but the brightest tones and the fruits appear quite round and solid. The light from a window illuminated them and I used a reflector on the opposite side to bounce some light back into the shadows to reduce the contrast to a more acceptable level.

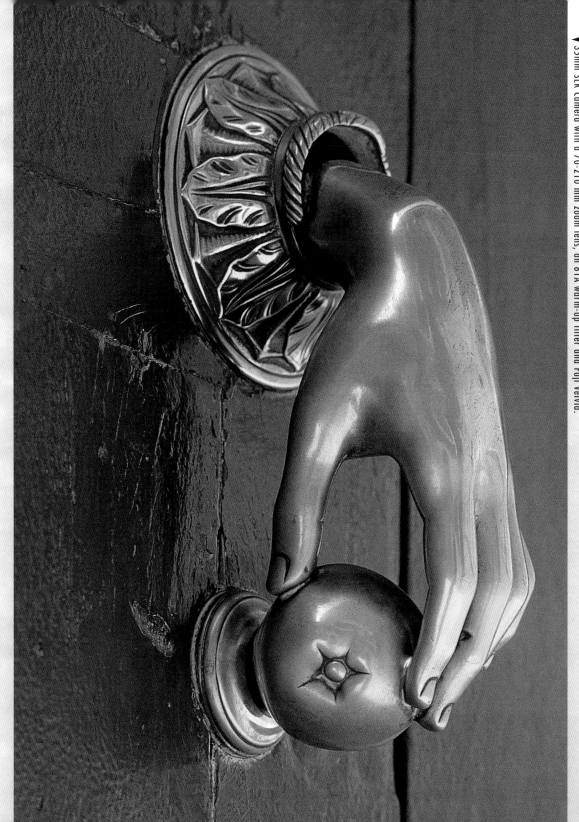

Technical Details
35mm SLR Camera with a 70-210 mm zoom lens, an 81A warm-up filter and Fuji Velvia.

Shapes & Patterns

All photographs depend for their effect on a number of individual visual elements and the most successful photographs are usually those in which one or more of these elements is boldly and clearly defined. The outline or shape of a subject is the element which usually first identifies it and a photograph with a well defined shape invariably has a strong initial impact. A pattern is created when a distinctive shape is repeated within the image and it can have a powerful impact when used as part of a composition.

Seeing

I came across this display of coloured beads while wandering through the souk in Marrakesh, Morocco, and the bold colours combined with the strong shapes appealed to me enormously.

Thinking

In normal circumstances a subject that contained as many different, and dominant, colours as this would be likely to produce a confusing and distracting image. But here, the repetition of the shapes had created the impression of a pattern and imposed a sense of order in the image.

Technical Details
▼ 35mm SLR Camera with a 35-70 mm zoom lens, an 81A warm-up filter and Fuji Velvia.

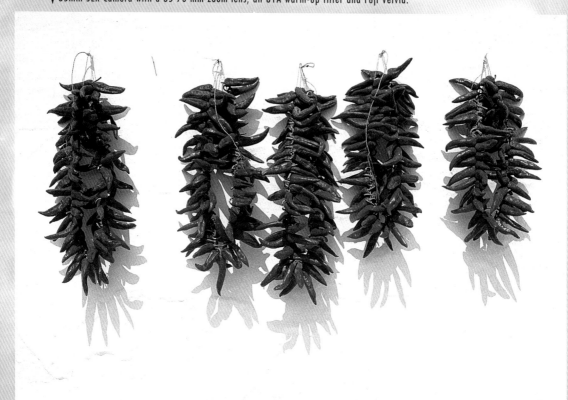

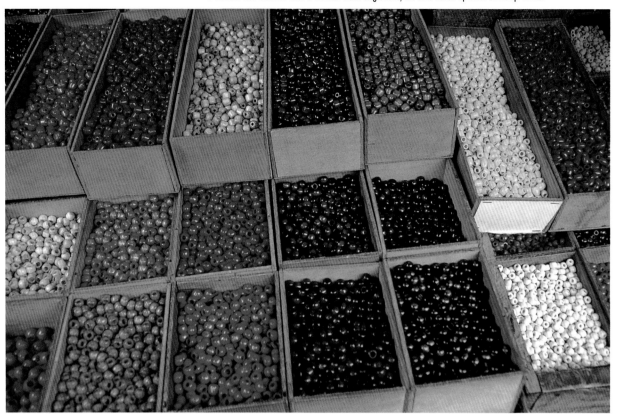

Acting

I took up a very close viewpoint and used a wide-angle lens, which enabled me to look down on the boxes as well as allowing me to include a larger area of them. I tilted the camera just a little to one side so that the sides of the boxes weren't completely parallel to the edges of the frame and selected quite a small aperture to ensure I had adequate depth of field.

I saw these peppers, hung out to dry in the sun, while travelling through a Spanish village. The picture appealed to me for two main reasons, I liked the effect of the single bold colour against the white background and the interesting shapes they had created also appealed to me. I framed the image so that there was a balance between the white wall and the peppers, and I gave one stop more exposure than the meter indicated to compensate for the very bright wall.

Rule of Thumb

To exploit fully the shape of a subject you must ensure there is a good tonal or colour contrast between it and the background. Lighting too can help to create bold shapes when the subject is lit more strongly than its background, or when it is backlit so that a halo of light defines its outline.

Shapes and Patterns

Seeing

The rich colour of this vegetable display, seen in a Sri Lankan market, made this a subject I could not pass by. But it was also the unusually ordered way in which they had been stacked, which made the picture truly irresistible.

Thinking

My first thought was to exclude all other details except for the vegetables themselves but this resulted in an image that was too stark and graphic. I realised that I needed to show something of the setting and the fact that this was a market.

Technical Details

▼ 35mm SLR Camera with a 35-70 mm zoom lens, an 81A warm-up filter and Fuji Velvia.

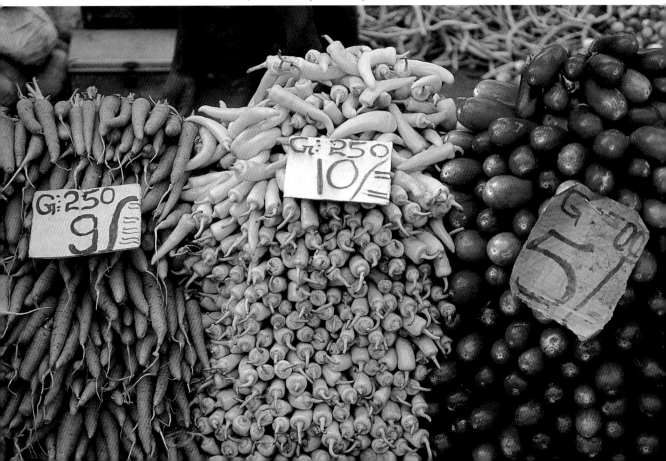

Technical Details

▼ 35mm SLR Camera with a 35-70 mm zoom lens, an 81A warm-up filter and Fuji Velvia.

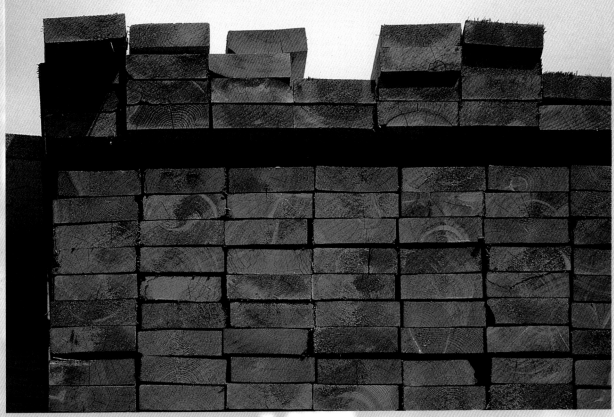

I found this pile of wooden planks in a local builder's yard and was immediately attracted by the curiously intense colour of the preservative with which they had been painted. It made them almost seem to glow. I framed the image in a way that emphasised the pattern of the plank ends and which allowed me to include an area of sky at the top to make the most of the shape created by the red wood.

Rule of Thumb

Tight framing, and the exclusion of less relevant details, are a way of emphasising a subject's pattern and can add considerably to the impact of an image. But it invariably improves the picture if there is an element or detail that breaks the pattern in some way.

Acting

For this reason, I framed the shot so that the tops of the vegetable piles were included and I allowed the small table to be visible in the top left-hand corner of the frame. This framing also placed the price tickets in the most balanced way.

Exploiting Texture

The medium of photography is especially effective at conveying an impression of texture. This is a quality that can be particularly powerful in close-up and still life photography as it can give an image a very tactile quality and this in turn will greatly enhance photographs of subjects like food, fabrics and natural forms. Texture, effectively, is the form within an object's surface: the subtleties of an image's tonal range are needed to reveal it effectively and the direction and quality of the light falling on the subject will determine these.

I spotted this detail on the rusting gateway to a derelict chateau in France. Although it was a cloudy day and the subject was very softly lit, the deeply embossed emblem and the heavily rusted paintwork gave an image with a quite tactile, textural quality. The limited colour range of the picture has also contributed to this effect.

Technical Details
▼ 35mm SLR Camera with a 24-85 mm zoom lens, an 81A warm-up filter and Fuji Velvia.

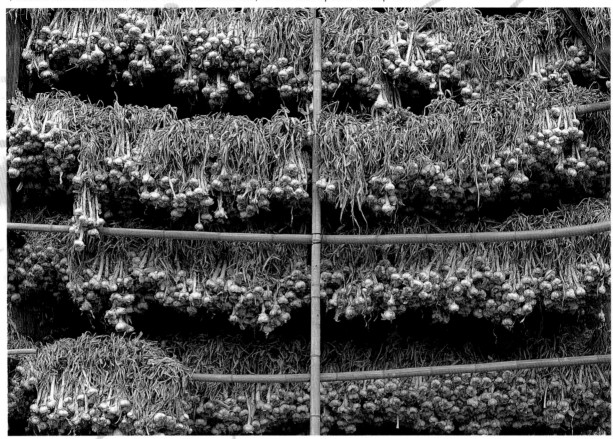

Seeing

While travelling through Gascony, in France, I came across this barn hung with skeins of garlic left to dry in the sun. It was the quality of the **light** that especially caught my eye and this had created a wide range of **tones** even though the subject itself was virtually **monochromatic**.

Thinking

I explored various possibilities, beginning with a closer viewpoint where the individual strings of garlic were much larger in the frame. Eventually, however, I became aware that if the garlic was featured much smaller in the frame it would create a **textural** effect and this seemed to me to be more interesting.

Acting

I framed the shot, using a **long-focus zoom lens**, so that the upright pole supporting the strings of garlic was placed in the centre of the image, together with one of the horizontal supports. This has created an element of **symmetry** in an otherwise quite untidy image.

Rule of Thumb

A critically sharp image is a vital factor in enhancing the effect of texture in a photograph. It's best to use a slow, fine-grained film for maximum definition together with a tripod to eliminate the risk of camera shake. You should also make sure that the aperture you select is small enough to provide enough depth of field for all the important details to be rendered sharply.

Exploiting Texture

Technical Details
▼ Medium Format SLR Camera with a 105-210 mm zoom
 lens, an 81A warm-up filter and Fuji Velvia.

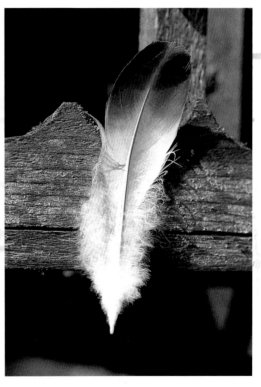

Seeing

The ancient stone of this old barn, seen on the edge of a
French village, caught my eye as I drove by and I stopped to
explore the possibilities. The autumnal creeper was
also a striking feature of the scene and I began to see various
ways in which I could approach the picture.

Thinking

On a more careful look at the barn I noticed that the
weathered wooden door had taken on a colour which
almost echoed the colour of the ivy leaves and I felt that this was
something which I could make use of. I also became aware that
the individual textures of the wood, stone and leaves
seemed to be enhanced when they were juxtaposed with
one another.

Acting

I chose a viewpoint that placed my camera square on to
the wall of the barn and then framed the image
so that the wooden door and stone wall occupied
almost equal areas of the image. Then I raised the
frame to include just enough of the ivy to
balance the composition.

▲ Technical Details

Medium Format SLR Camera with a 105-210 mm zoom lens and Fuji Velvia.

This almost abstract picture was taken in a junkyard, a marvellous hunting ground for close-up shots. Although very softly lit the jaggedness of the subject has created a quite tactile quality. I framed the shot in a way that placed the light-toned piece of metal across the diagonal and gave half a stop less than the meter indicated to create a moody, low-key image.

◄ Technical Details

35mm SLR Camera with a 90 mm macro lens and Fuji Velvia.

The lighting for this shot by Julien Busselle was provided by direct sunlight and is quite hard and directional. It helped to accentuate the subtle texture of this feather very effectively and the monochromatic quality of the image has enhanced it further.

Rule of Thumb

As a general rule, subjects with bold, deeply indented textured surfaces will be more effective when lit with a soft, fairly frontal light, whereas those with a more subtle texture need a less diffused and more acutely angled light to enhance them.

Framing the Image

There is a widely quoted rule of composition that the image should be framed so that the main point of interest is placed where lines dividing the image into thirds intersect. While this will, in most cases, produce a pleasing effect it is by no means something which should be followed slavishly and it is important to consider the overall balance of the image before deciding on the way it is framed.

I framed this shot so that the dominant shapes of the white painted segments were placed just below the centre of the image and this allowed all of the red tips to be shown while extraneous details immediately to each side of the floats were excluded.

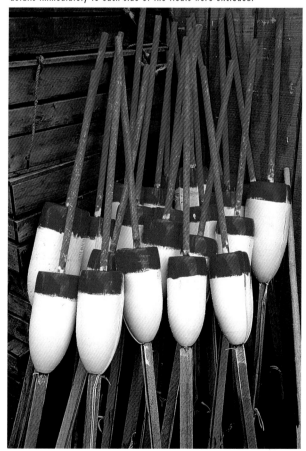

Seeing

The mirror-like calm of the water in this Scottish harbour attracted me initially to this scene because the reflections from the moored boats were so strong and undistorted.

Thinking

The question of how much of the boat to include was the main consideration and I began by thinking in terms of a landscape shape which showed the whole of the craft. But this resulted in what I felt was the most interesting part of the reflection, the lettering, being too small in the image.

Acting

When I switched to an upright frame I found that everything began to fall into place. Using my long-focus zoom lens I found I was able to place the line between the boat and its reflection in the centre of the image and I was able to crop it tightly enough to exclude all the irrelevant details.

The diagram shows how the impact of this picture would have been lessened if more of the scene had been included.

▲ Technical Details

35mm SLR Camera with a 24-85 mm zoom lens, an 81A warm-up filter and Fuji Velvia.

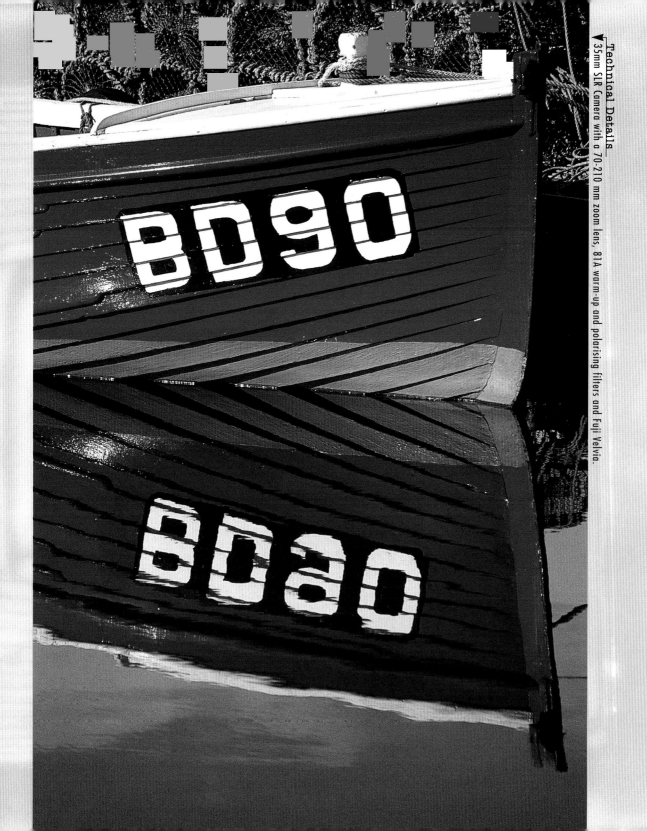

Technical Details
▼ 35mm SLR Camera with a 70-210 mm zoom lens, 81A warm-up and polarising filters and Fuji Velvia.

Framing the Image

Rule of Thumb

Although it might seem wasteful, you can learn a great deal, and can help to develop your approach to composition, if you sometimes shoot several alternatives to a picture, experimenting with different framing. There is no better way of discovering how best to approach this aspect of photography than by being able to make direct comparisons. I often do this and am frequently surprised to find I prefer the version that I thought was going to be less successful.

Seeing

It was the combination of the wet, grey pavement and the metal grill with the bright, golden colour of the fallen leaves that caught my eye in this shot, taken in Paris.

Thinking

I wanted to keep the image as simple as possible, almost abstract, as I felt that the grill was so distinctive and typical of a Parisian street that I needed to include little else to create a sense of place. I also wanted to restrict the image to just these two colours.

Acting

I used a standard lens and a fairly close viewpoint that excluded most of the surrounding details and allowed me to look down on the grill. I framed the shot so the circular shape of the grill was placed off-centre, just touching the edges of the picture, and in a way which included the reflection and highlight on the right hand side of the image to create a balance.

Technical Details

35mm Viewfinder Camera with a 45 mm lens, an 81B warm-up filter and Kodak Ektachrome 100SW.

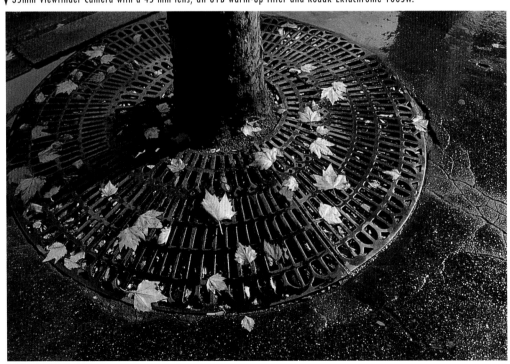

Technical Details
35mm SLR Camera with a 70-210 mm zoom lens, an 81A warm-up filter and Fuji Velvia.

This is a photograph of one of the numerous beautiful doorways in the palace of Jaipur, India. For this I felt a very straightforward approach to framing the image would be the best course. I wanted the image to be completely symmetrical, effectively aiming for a flat copy of the door, as if it were a painting. I used a fairly distant viewpoint to avoid any feeling of perspective and then placed my camera directly opposite the door's centre, framing the image so that the borders of the doorway fitted just inside the edges of the picture.

Using Daylight

While it's worth bearing in mind that many items of studio lighting equipment, and the techniques employed alongside them, are designed to emulate the effect of daylight, there's no beating the real thing. It may have the disadvantage that it is unpredictable and difficult to control, but daylight is still the means by which the majority of photographs are taken and with subjects like landscapes it is the only practicable light source. Therefore knowing how to use daylight and manipulate it to the best advantage is vital to the success of all outdoor photographs.

Rule of Thumb

Remember that daylight varies considerably in terms of its colour temperature as well as its intensity and quality. In conditions such as an overcast day, or in open shade when there is a blue sky, daylight can be very cool in colour, and will produce a bluish colour cast on transparency film. The use of a warm-up filter such as an 81A, B or C will remove the colour cast and create a more pleasing image.

Technical Details
▼ Medium Format SLR Camera with a 55-110 mm zoom lens, an 81A warm-up filter and Fuji Velvia.

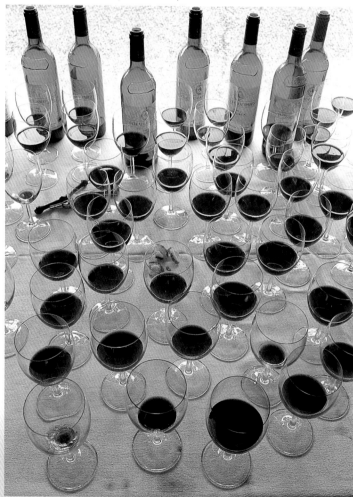

I saw this impromptu still life of wine glasses while visiting a French chateau. They had been left behind after a wine tasting and I liked the haphazard arrangement of glass which, nevertheless, seemed to have a harmonious and balanced quality. I chose a viewpoint that enabled me to shoot towards a large window, which has produced this softly lit but quite striking effect.

Technical Details

▼ 35mm SLR Camera with a 24-85 mm zoom lens, an 81A warm-up filter and Kodak Ektachrome 100SW.

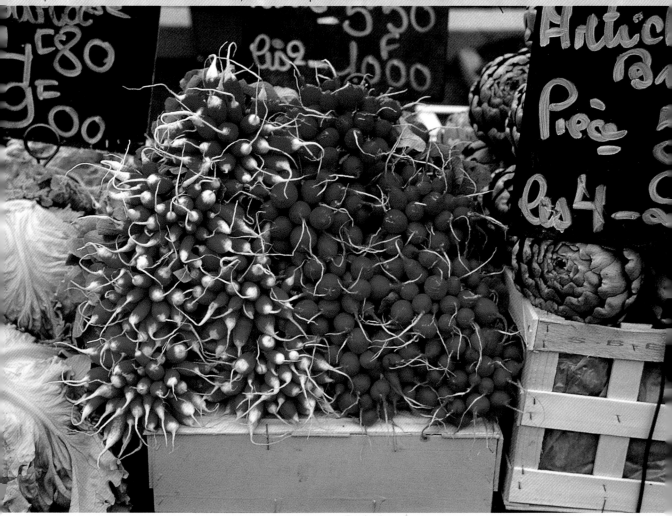

Seeing

It was a very dull, overcast day and the lighting quality was very soft and flat. I was shooting pictures for a travel brochure and it was not possible to photograph subjects such as landscapes and buildings because of the poor quality of the light.

Thinking

On occasions like these I will often seek out subjects like this French market scene, as many close-up and still life images are more pleasing when photographed with soft lighting, especially when they contain bright, saturated colours.

Acting

The pile of bright red radishes was the focus of my attention and I used a close viewpoint together with a long-focus lens in order to make them large in the frame. I included a little of the detail on each side of the vegetables together with the price signs above. This helped to contain the subject and provided an element of contrast, which heightened the impact of the radishes.

Using Daylight

Technical Details

▼35mm SLR Camera with a 90 mm macro lens and Fuji Velvia.

Hazy sunlight was illuminating these Rowan berries and creating some attractive highlights on their glossy skin, but because the sunlight was partially diffused it prevented the shadows from becoming too dark and there were a good range of tones in the image. I used a macro lens from a close viewpoint to fill the frame with the best-looking cluster of berries and set a small aperture to obtain sufficient depth of field. Even so, only a few of them were sharp.

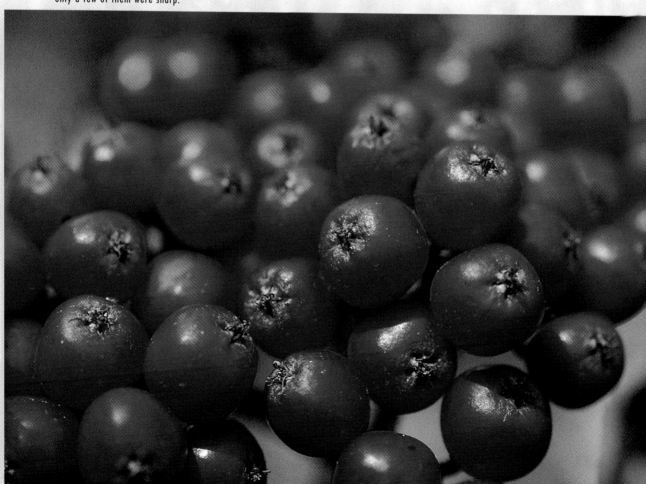

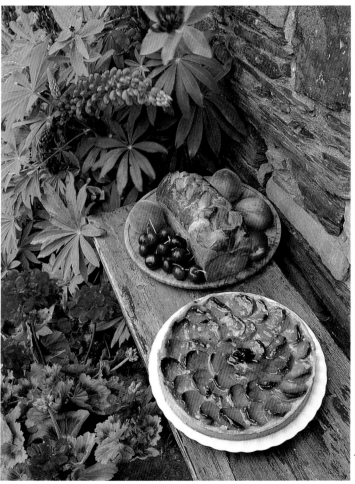

Seeing

I wanted to shoot an informal still life set up for a food illustration in a travel brochure and had chosen these items from a French patisserie. I'd previously arranged to photograph them in the garden of a rustic cottage where there were a variety of possible backgrounds.

Thinking

I needed to find a suitable surface to place the dishes for this particular set up, one which would allow me to use a high viewpoint to show the most important features of the food. This small bench beside the cottage wall was ideal as it also provided an attractive and atmospheric setting.

Acting

It was a very dull, overcast day, and had been raining, but the light was ideal for this picture as it was directed from the sky directly above the set-up, which allowed some attractive highlights to be created on the fruit and brioche crust.

Technical Details
Medium Format SLR Camera with a 55-110 mm zoom lens, an 81A warm-up filter and Fuji Velvia.

Studio Lighting

There's a belief that studio lighting is rather complex and difficult and requires a considerable amount of expensive equipment. This is simply not true, and many of the best still lifes and close-ups are taken using just one or two simple light sources that can be set up in any convenient room. Even something as basic as an anglepoise lamp, a mirror and a piece of white card can be used to create a wide range of effects.

I lit this still life of fungi with a single flash placed about one metre away from the set up and 250cms above it. I then placed a diffusing screen about halfway between them with a white reflector on the opposite side, adjusting its distance until I had the right balance between the highlight and shadow areas.

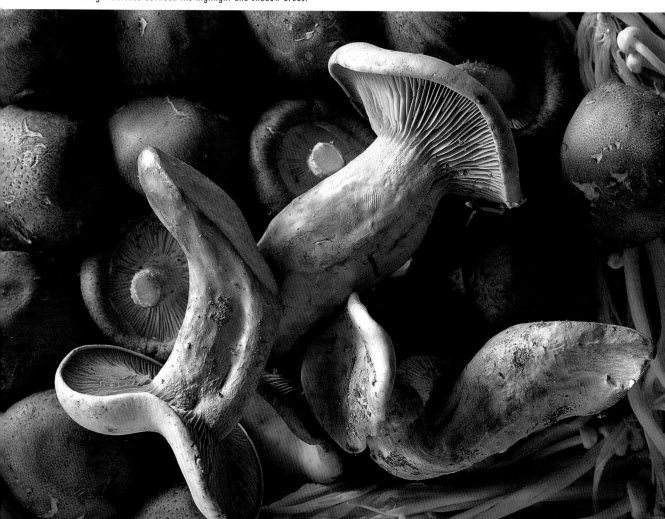

Technical Details
35mm SLR Camera with a 90 mm macro lens, an 82A light balancing filter and Fuji Velvia.

Seeing

I wanted to find a way to photograph these dried grass heads so that the spiky detail was accentuated along with their rich golden colour. My first attempt at lighting them conventionally on a white paper background was not very satisfactory as the shadows that were cast tended to obscure the detail of the plant's outline.

Thinking

It occurred to me that I might get the effect I wanted if I used a light box as a background, since this would provide a white background and could also be used to eliminate the shadows cast by the main key light.

Acting

I arranged the grasses on an ordinary photographic light box. With this illumination alone the grass heads were effectively silhouetted so I brought in an anglepoise lamp, and then adjusted its height and distance until I achieved an acceptable balance in the brightness level between this and the light box and there was good modelling in the grasses.

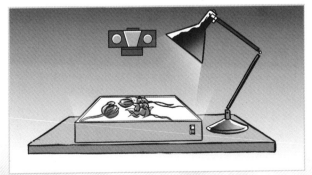

The lighting set up for this picture of dried grasses is shown here.

Technical Details
Medium Format SLR Camera with a 55-110 mm zoom lens and Fuji Astia.

Studio Lighting

Seeing

I had visualised a very simple image that would have just **two colours**, a plain blue paper background and the red chili. The most important thing was to light the steel fork so that it was bright enough to create a highlight in the image but it still needed to retain a feeling of **depth** and **form**.

Thinking

Using **reflected** light was the best way to produce the quality I wanted on the fork and I placed a large white reflector quite close to it on the right-hand side with a **single flash** aimed at this to establish the basic lighting.

Acting

I then aimed a **second flash** at the background and adjusted its brightness until the density of the blue paper matched the highlight on the fork. But the shaded side of the fork was very dark so I placed a reflector close to it on the left-hand side and angled it until this side of the fork almost matched the other for brightness. There was one remaining small area of dark tone on the fork, which I removed by placing a **third reflector** below it.

Technical Details
▼ Medium Format SLR Camera with a 105-210 mm zoom lens and Fuji Astia.

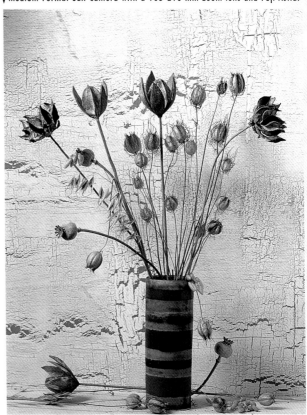

Rule of Thumb

When using more than one light to illuminate a subject you should begin by establishing the position of the key light: this is the one which will create the shadows and establish the image's basic form and texture. Additional lights can then be added where required to make the shadows lighter, to add additional highlights or to illuminate the background, but you must take care when setting these up not to introduce secondary shadows.

I wanted a fairly neutral background for this arrangement of dried grasses but one that wasn't completely plain. So I painted a sheet of hardboard with a grey paint and then a coat of crackle glaze which, when painted over again with off white, created this peeled effect. The lighting was achieved by placing a large white reflector about two metres from the set-up and almost at right angles to it on the left-hand side. I then aimed a single flash at it from about two metres away, taking care to shield the still life from light spill. A further large white reflector was also placed on the opposite side to bounce a little light back onto the scene.

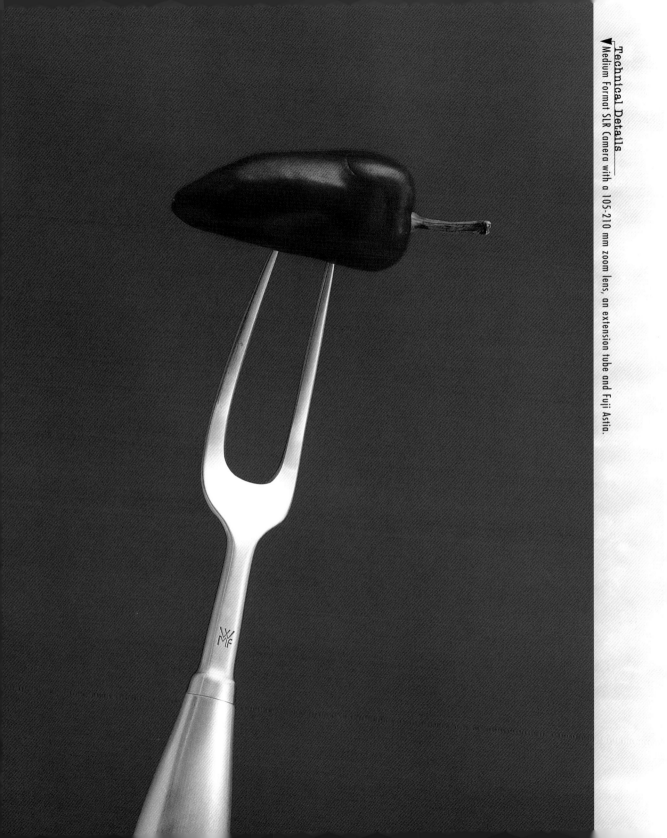

Studio Lighting

Rule of Thumb

When using flash you may find your choice of aperture limited by the power of your flash unit and in some circumstances this might not be small enough to provide you with adequate depth of field. With static subjects like a still life you can overcome this by using your camera's multiple exposure setting to give additional exposures. Two flashes will allow you to set one stop smaller, four flashes two stops and so on. It is vital, of course, that the camera is not moved until the sequence is complete.

Seeing

This still life of foie gras was set-up on location in a restaurant and I wanted to try and show something of the atmosphere of the setting. I chose this table as there was a window behind and I felt the wall coverings and curtains would have been too distracting.

Thinking

The main thing to consider here was the arrangement of the illumination so that the lighting for the dish and the table setting was balanced with the daylight coming through the window and the intensity of the table lamp.

Acting

I first took a reading to determine the exposure needed for the window and then took a reading from the flash that I was using to illuminate the table setting. This was a single flash diffused by a reflection umbrella and it was placed close to the table to the left of the camera. I then adjusted the shutter speed for the window exposure so that the aperture needed for this was the same as that required by the flash. At this exposure, the table lamp was a little too bright so I replaced the bulb with one of lower power to ensure that this too would give a correct exposure at the set aperture.

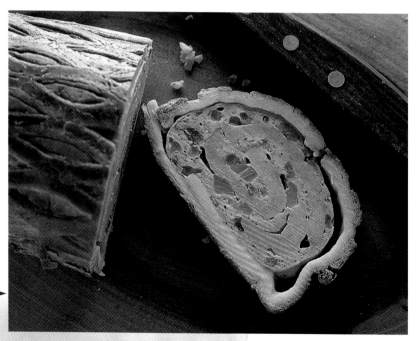

I lit this still life of pate en croute using one small portable flash and a reflector. The flash was placed slightly behind the set-up and only just above it and was diffused by a white umbrella. I then placed the reflector in front of the arrangement, adjusting its distance until the shadows were reduced in density just enough to prevent them from being jet black.

Technical Details ➤
Medium Format SLR Camera with a 105-210 mm zoom lens, an extension tube and Fuji Velvia.

Technical Details
Medium Format SLR Camera with a 50 mm wide-angle lens and Fuji Velvia.

Photographing Glass & Metal

Both glass and metal objects have especially intriguing possibilities for the photographer because of their ability to reflect light in a very directional way. In the case of glass, its ability to transmit as well as to reflect light gives further options as to the way it is lit and adds to its potential to produce interesting images.

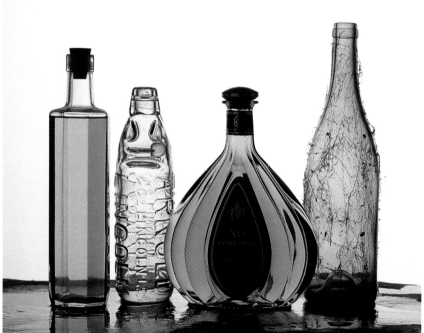

Technical Details
Medium Format SLR Camera with a 105-210 mm zoom lens and Fuji Astia.

Seeing

I wanted to exploit the transparent nature of these glass bottles and to photograph them in a way that used their **varied shapes** as a dominant element in the composition.

Thinking

Bearing both of these considerations in mind, I decided that the bottles would be most effectively photographed against a light-toned background and that the **transparent** quality of the glass would be greatly enhanced if this background were lit strongly enough to become the dominant light source. I also felt the composition would be more interesting and balanced if I filled two of the bottles with coloured liquid.

Acting

I set the bottles up on a shelf about three metres in front of a white paper background and lit this with a **single flash** placed on the floor below the shelf. I then placed two **white reflectors** each side of the set-up to add some highlights to the darker facets of the moulded glass.

I pushed this wine bottle through a large cobweb found in my garden shed to create an element of texture and interest. Then I chose this piece of scrap metal for a background, since I felt the combination of blue and green would be effective. I lit the bottle by bouncing a single flash from a white reflector placed about one metre from the bottle on the right-hand side and then added another reflector on the opposite side to create an additional highlight on the glass.

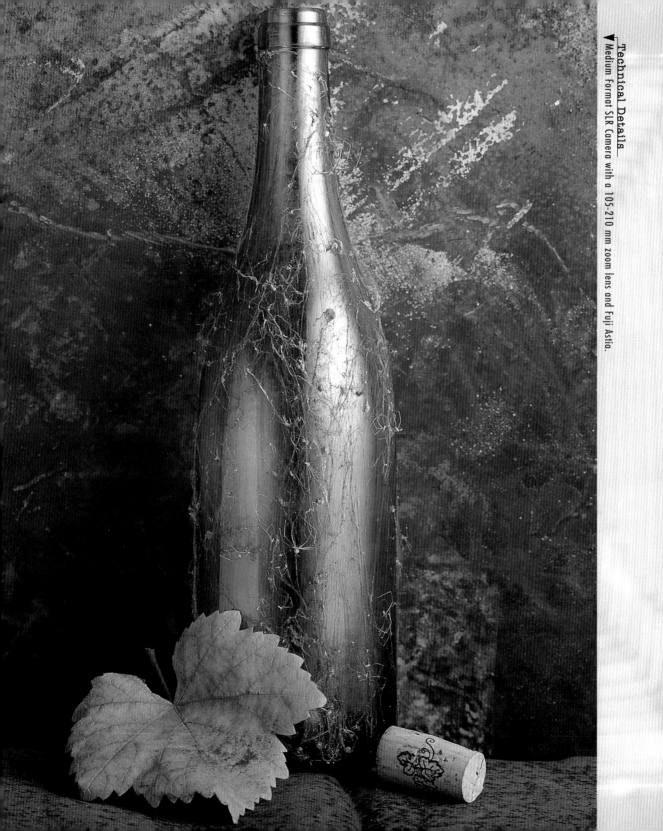

▼ Technical Details
Medium Format SLR Camera with a 105-210 mm zoom lens and Fuji Astia.

Photographing Glass & Metal

Seeing

I wanted to photograph this small silver medal in a way that revealed the **detail** of its **surface** while giving it a feeling of form and solidity. Because the object was so small, the space between it and the front of my macro lens was very narrow and I was limited to the ways in which I could light it.

Thinking

I could have used a **ring flash** but I felt this would create a rather **flat** image, and it wouldn't have accentuated the form and texture of the medal's surface in the way I had visualised.

Acting

I overcame the problem by placing a piece of optical quality **resin** - glass would do - immediately in front of the lens at an angle of 45 degrees. I then placed a light source, an **anglepoise** lamp in this case, at right angles to the camera, level with the resin, as shown in the diagram. This enabled the light to be **reflected** straight onto the medal: just a small adjustment to the angle of the resin and the lamp produced this effect.

The lighting set-up for the close-up of the medal is shown here.

Technical Details

▼ 35mm SLR Camera with a 90 mm macro lens, an 82A light-balancing filter and Fuji Velvia.

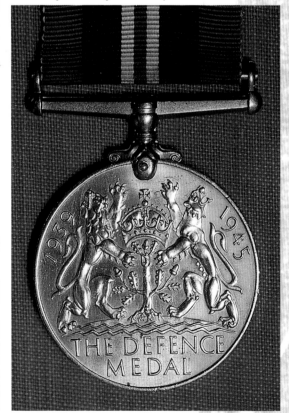

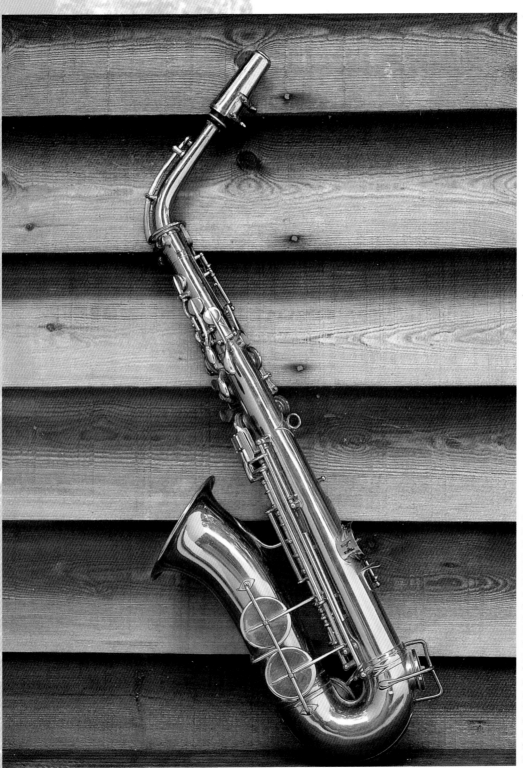

Technical Details
Medium Format SLR Camera with a 55-110 mm zoom lens and Fuji Velvia.

For this set-up I used the light of an overcast sky, while my garden shed provided the background. I thought the colour of the weathered wood echoed that of the saxophone and I liked the effect of the limited colour range. I used two white reflectors to control the lighting, one immediately in front of the camera angled upwards and another close to the saxophone on the right-hand side.

Still Life Arrangements

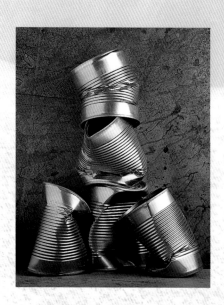

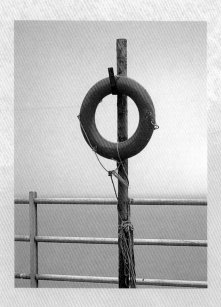

3

Still life photography is as much about
ideas as it is about photographic technique or equipment. The professional still life photographer
has to work with the brief his clients give him and this often involves expensive objects and
complex set-ups. But when shooting pictures for your own personal pleasure, or as a means of
self-expression, you don't need to be restricted to the type of still life
photograph seen in the glossy magazines. Many very ordinary,
everyday objects can be used to create interesting images and the
simplest set-ups are often the most striking.

Concept & Design

With the exception of those ready-made still lifes found by chance, images of this type have to begin with an idea. The idea may be inspired by a particular object, a setting, a background or even a lighting or camera technique but every still life image needs a starting point of some sort.

Seeing

For this arrangement of asparagus, Julien Busselle wanted to shoot a close-up image that would accentuate the shape and texture of their tips.

Thinking

He experimented initially with a fabric background but the lighting that was most effective in revealing the subtle texture of the vegetables cast shadows onto this, with the result that the shape of the asparagus was partially concealed.

Acting

For this reason he decided to place the asparagus on a sheet of plain glass, which was supported about a metre above a large piece of white paper. He lit this using two flash heads - each fitted with barn doors to ensure the light did not spill onto the glass - which were placed just below and to each side of the set-up. He then placed another flash, diffused by a soft box, quite close to the asparagus and adjusted the intensity of this until there was a good balance between the white background and the asparagus.

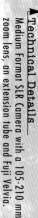

Technical Details
Medium Format SLR Camera with a 105-210 mm zoom lens, an extension tube and Fuji Velvia.

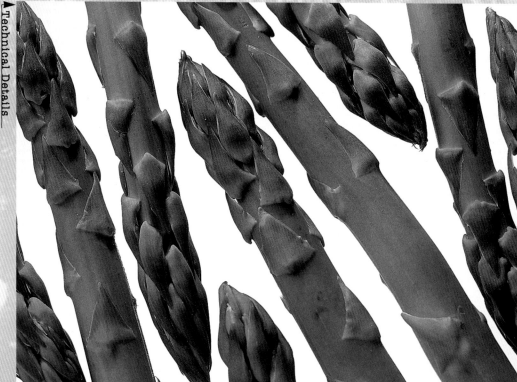

Technical Details

▼ Medium Format SLR Camera with a 105-210 mm zoom lens and Fuji Astia.

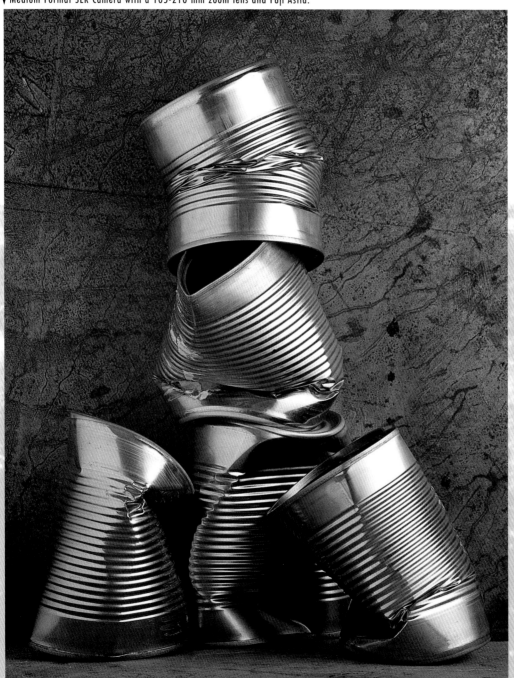

I accumulated this collection of used cat-food tins - the cats we have get very hungry - with a view to using them in some way at a later date. It was not until I found a piece of oily, rusting sheet metal in a junkyard that the idea of combining them came to me, but I liked the juxtaposition of the pristine and tatty metuls along with the almost monochromatic quality it created.

Concept & Design

Seeing

This is an opportunist picture, which began simply with the wish to shoot a still life of fish. I was staying at the time on the coast in Spain and the local fishmonger always had a selection of interesting-looking fish on his slab but I had not resolved how to use them.

Thinking

While taking a walk on the beach one day I noticed a rather shabby fishing boat with peeling paint, which was this rather attractive colour. I thought this would make an ideal background for my fish and there was a hatch cover, which I could lift down and place in a more convenient position.

Acting

Having bought my fish, all that remained was to arrange them on the board to create a balanced composition. It was a sunny day so I set the board up in a shaded spot as I wanted the fish to be softly lit and without noticeable shadows.

Technical Details
Medium Format SLR Camera with a 55-110 mm zoom lens and Fuji Velvia.

Rule of Thumb

When setting-up a still life arrangement it's best, having decided on your background, to start with one object; usually that which has the most dominant shape or colour. You can then progressively add the other items, checking through the viewfinder as you go - replacing, rejecting or relocating items if necessary - until you arrive at the most pleasing and balanced composition.

Technical Details
▼ 35mm SLR Camera with a 24-85 mm zoom lens and Fuji Velvia.

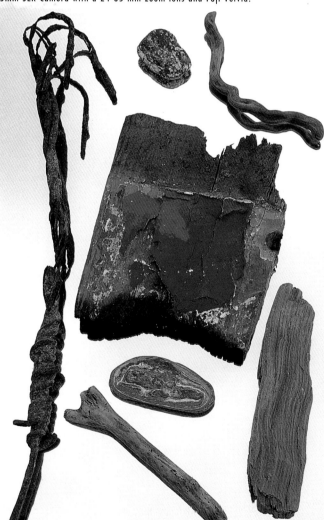

This picture also evolved as a result of my walks on the same beach. I'm a bit of a beachcomber at heart and I tend to accumulate a variety of objects; these range from the obvious shells to bits of driftwood, rusting metal and, on this occasion, what appears to be a small piece of wrecked fishing boat. In order to create a slightly unusual quality I set my objects up on a large piece of mirrored glass and angled this upwards so that it reflected the sky.

This diagram shows the set-up for the beachcomber's still life.

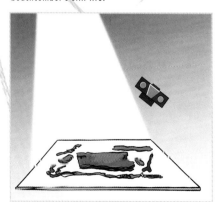

Concept & Design

I bought this assortment of tropical fruits in order to set-up a conventional still life arrangement but later I felt it was worth exploring other possibilities. This particular idea stemmed from thinking that the texture of the soft-skinned shiny fruits could look interesting if they were juxtaposed against this piece of rusty metal. I stacked them in this way partly because I thought it would make a rather unusual composition but also because I wanted the fruit to be in contact with the metal to accentuate the image's tactile quality.

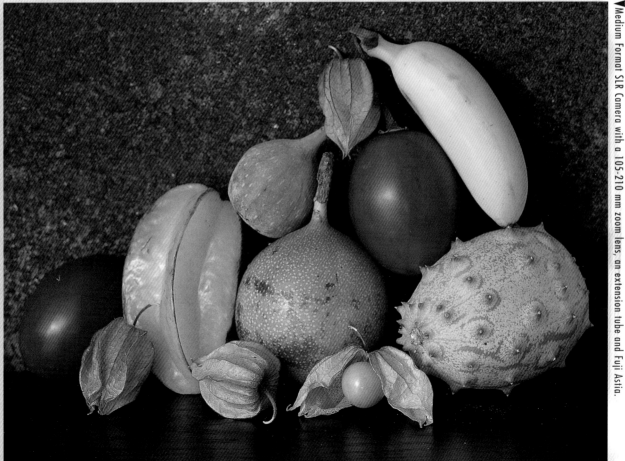

Technical Details
Medium Format SLR Camera with a 105-210 mm zoom lens, an extension tube and Fuji Astia.

Rule of Thumb

Remember that visual contrasts can be very
powerful elements of an image. I'm talking here
not only about the tonal contrast created by
lighting, but also the contrast between shapes,
textures, colours and patterns; it pays to think of
opposites when choosing other objects, props or
backgrounds to combine with your central object.

Technical Details
▼ Medium Format SLR Camera with a 105-210 mm
zoom lens, an extension tube and Fuji Velvia.

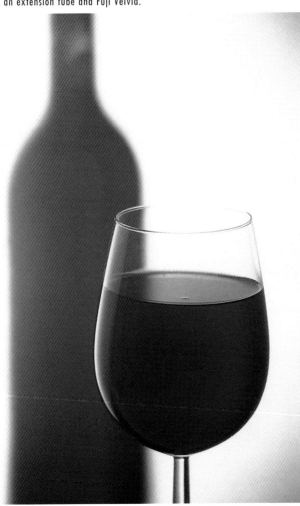

Seeing

The classic shapes of a wine bottle and
glass were the inspiration for this
arrangement by Julien Busselle. He
wanted to produce an image in which
shape was the dominant
element but at the same time he planned
to introduce another quality which would
make the picture a little out of the
ordinary.

Thinking

He reasoned that if he filled his bottle and
glass with the same coloured liquid -
diluted red wine - and then used a white
background to accentuate the
shape and transparency of his
subjects, he could achieve both aims.

Acting

Julien set his subjects up on a shelf about
two metres away from a white paper
background, which he lit with a single
flash. He than placed a large white
reflector close to the camera and
bounced another flash off this to create
strong highlights on the glass. In
order to avoid a cliched image of these
two very familiar objects, he placed the
wine glass well into the foreground and
cropped into the bottle, selecting an
aperture that rendered it slightly
out-of-focus.

Concept & Design

Rule of Thumb

A good way of seeking inspiration for ideas is to imagine that you have been briefed to provide an image to illustrate a particular theme. You could, for example, visualise an image to illustrate a CD cover for, say, Vivaldi's Four Seasons, or it could be for a book you particularly like, or perhaps to illustrate a poem or a magazine article on a subject close to your heart.

Seeing

The idea for this picture came from a wonderful book by Andy Goldsworthy, an artist who works with natural elements - such as wood and stone - within the landscape. He effectively makes sculptures from things that are a living part of the setting in which he finds them, objects that may often exist for only a short time.

Thinking

All I did was to use this concept to make a simple Still life arrangement of objects - pieces of driftwood which I'd collected - I then placed them in the setting of the beach where I found them.

Acting

I wanted this arrangement to be as uncontrived as possible, just a simple grouping of related objects which were only one stage removed from the way I'd found them. In order to give the image a more interesting quality I waited until the sun had set before shooting, a decision that also helped to make the picture a little more atmospheric.

Technical Details
▼ 35mm SLR Camera with a 35-70 mm zoom lens and Fuji Velvia.

This picture came about because I caught this rather fine brown trout one day. I took it home and laid it on a piece of slate which I flooded with water; then I added the rod and reel to add interest to the image and to provide an additional element of composition. I used natural light - open shade on a sunny day - and I fitted an 81A warm-up filter to counteract the blue cast this scene would otherwise have suffered from.

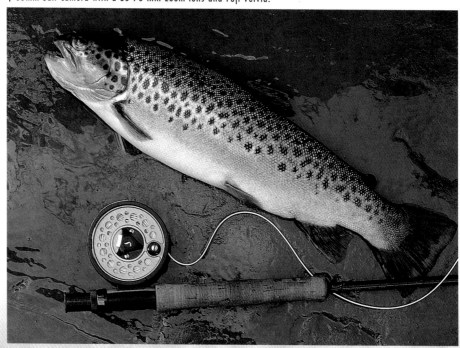

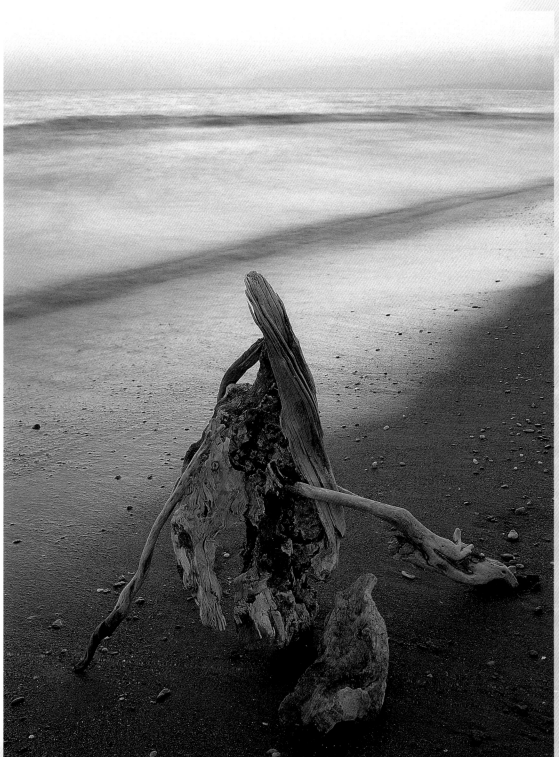

Technical Details
Medium Format SLR Camera with a 50 mm wide-angle lens and Fuji Velvia.

Backgrounds & Settings

In many fields of photography the choice of background is given little thought and, at best, is something that is treated rather like a Victorian child; seen but not heard. But in still life photography, the background is a vital element of the composition and can be as important to the success of an image as the arrangement placed in front of it.

Rule of Thumb

It's a good idea to accumulate a small collection of bits and pieces, which can be called upon to contribute to a background or setting. A demolition site is an excellent place to find pieces of wood with peeling paint, for instance, and I visit the neighbourhood junkyard occasionally to see what they have that could be useful.

Seeing

I'd bought these ornamental gourds because they were so attractive but I had no firm idea of how I would use them. I was primarily attracted by their colour, which ranged from grey-green to yellow, amber and orange.

Thinking

My first thought was to use a background that created an element of contrast but, while pondering the problem, I came across a piece of old panelled wood and this bamboo table. It occurred to me that the colour quality of the pair was very sympathetic to the gourds and they seemed to echo the air of gentle autumnal decay.

Acting

I decided to continue the natural feel of the arrangement by setting it up outdoors in my garden and using just natural daylight. It was an overcast day and the soft light, which was directed mainly from over the set-up, was ideal and I had no need for a reflector to fill in the shadows since they were not at all dense.

The idea for this shot stemmed from a bunch of dried poppy heads hanging in our greenhouse. I couldn't find a suitable existing background for them around our home, so I decided to make one by plastering and painting a large piece of hardboard. After hanging the poppy heads, I chose and positioned the other items and lit the set-up using a lightly diffused flash, placed almost at right angles to the scene, with a reflector on the opposite side. This bounced light back, and allowed the density of the shadows to be reduced.

Technical Details — Medium Format SLR Camera with a 105-210 mm zoom lens and Fuji Velvia.

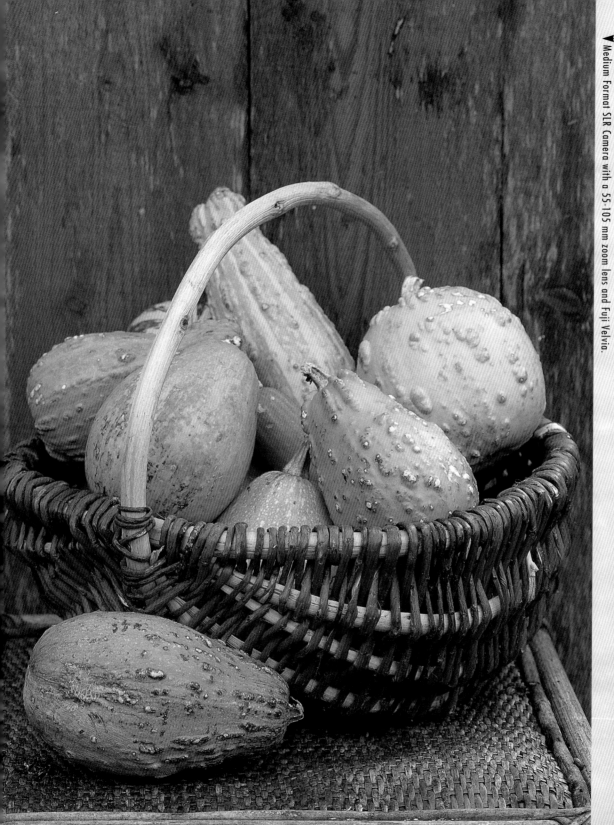

Technical Details
Medium Format SLR Camera with a 55-105 mm zoom lens and Fuji Velvia.

Backgrounds & Settings

Seeing

One of our old kitchen chairs was the starting point for this picture. I liked its shape and rough rustic quality and thought at first of using just its seat and back as a setting for a smaller arrangement.

Thinking

On reflection, I decided that cropping so tightly would lose much of the chair's appeal; the problem was that to show more of it meant that I needed to have a larger area of background and this consequently would become much more important in the picture.

Acting

In order to carry through the country-cottage theme, I rough plastered a large sheet of hardboard and painted it white and then placed the chair up against it. I felt the basket of squashes alone on the chair was not enough to make an interesting composition, so I added the small table with a pumpkin. I lit the set up using a single, lightly diffused flash, set almost at right angles to the subject and added a reflector on the opposite side to reduce the contrast.

Technical Details
▼ Medium Format SLR Camera with a 105-210 mm zoom lens, an extension tube and Fuji Velvia.

For this close-up shot of a fruit tart I wanted to use a setting which would convey a feeling of freshness and the outdoors. I placed the dish on the corner of a wickerwork picnic hamper and then positioned this close to a flower border; a careful choice of viewpoint enabled me to place a small section of this behind the tart. Then I set an aperture that threw the background details just a little out of focus, so they would not be too distracting.

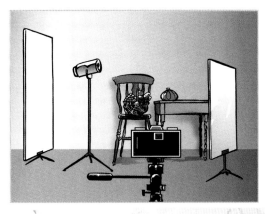

The set-up for this picture is shown here.

Rule of Thumb

When shooting still lifes out of doors it is generally best to avoid direct sunlight as the hard-edged, dense shadows and the bright highlights it creates are seldom sympathetic to subjects like these. The soft light of a cloudy day, or open shade when it's sunny, is invariably a more pleasing light. Sunlight can be made more manageable if diffused, and reflectors and fill-in flash can be used to control the contrast.

◄ **Technical Details**
Medium Format SLR Camera with a 105-210 mm zoom lens and Fuji Velvia.

Using Colour Creatively

In many fields of photography the colour content of an image is largely dictated by the nature of the subject. The photographer, through choice of viewpoint and the way in which the image is framed, has a degree of control over the way it features in the image, but it's fairly limited. But with still life photography, the choice of subject, background and props is all usually under the photographer's control and there is a much greater opportunity to produce pictures in which colour can be incorporated into the composition.

Seeing

I saw this opportunist still life while walking along the sea front on a dull, cloudy day and was immediately struck by the colour contrast between the red lifebuoy and the grey sea and sky.

Thinking

I also liked the contrast that was created by the shapes; the round lifebuoy and the rectangles of the railings. I decided to compose the image so that this too was exploited.

Acting

I chose a viewpoint that placed the top railing against the horizon line, where it didn't detract from the rectangular effect. Then I framed the shot so that the lifebuoy fell in the top half of the frame, just off centre, and this allowed me to include the railing support on the left-hand side of the picture.

Rule of Thumb

Colour is invariably most effective in an image when it is used sparingly. Pictures that are dominated by a single colour, or where one colour is combined with another contrasting hue, will almost always have greater impact than a multi-coloured image.

Technical Details ▶ 35mm SLR Camera with a 28-70 mm zoom lens and Fuji Velvia.

This simple still life of rocks and stones was made on a beach. I simply gathered an assortment, which were all shapes and sizes and placed some of them on a larger rock to create a balanced arrangement. The texture - which I enhanced with a splash of water - and the shapes of the stones, have been accentuated by the monochromatic nature of the subject. The photograph was taken in open shade on a sunny day and this has created a blue cast; I could have eliminated this by the use of a warm-up filter such as an 81B, but I felt that the image would be more effective if I let it remain.

▲ Technical Details
Medium Format SLR Camera with a 150 mm lens, an 81A warm-up filter and Kodak Ektachrome 64.

Using Colour Creatively

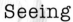

Seeing

I saw these pomegranates in the local market and thought that they would make an effective subject for a still life, largely because of the colour and texture of their skin and flesh.

Thinking

I experimented with various arrangements; at first I used a plain, contrasting background, but this was too obvious and I felt there was something lacking. Then I wondered whether the surface of this wickerwork table would do the job; I thought it would be effective because it echoed the colour of the fruits while its texture, and the pattern it created, provided an effective element of contrast as well.

Acting

I used a round terracotta dish, again a similar colour, to contain the pomegranates in the background. Then I placed the others so that they came forward towards the camera and by doing this I created a feeling of depth and distance, with the rich colour and highlights on the cut fruit creating a bold focus of interest. It was lit by shaded sunlight and I used a wide-angle lens to accentuate the perspective effect.

<u>Technical Details</u>
▼ Medium Format SLR Camera with a 50 mm lens and Fuji Velvia.

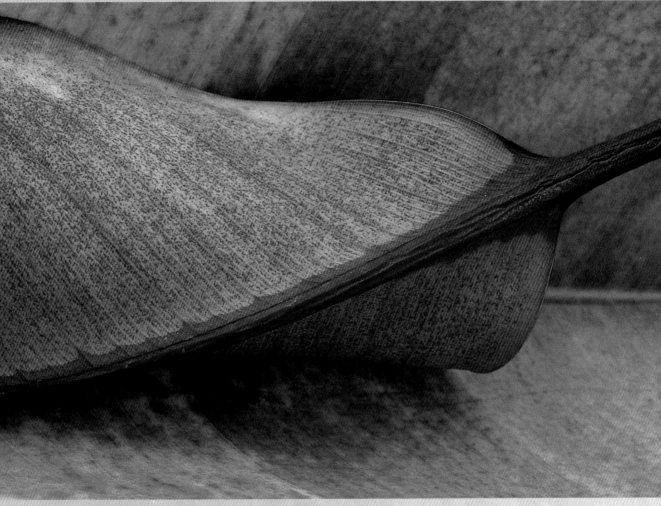

This very simple arrangement of rubber tree leaves works largely because of the colour contrast between the dead, curling leaf and that of the green leaf, which acts as a background. The sinuous shape the dead leaf has formed, together with its more pronounced texture, has also created an element of contrast.

Rule of Thumb

It's important to appreciate just how radically colour can influence the mood of a picture. Images in which the warm colours, such as red, yellow and orange, predominate will tend to have a cheerful and inviting quality. Photographs where the cooler hues of blue, greens and purple are dominant, however, will generally create a more subdued and introspective mood. In a similar way, bright, bold colours will have a lively and assertive quality while soft pastel colours will suggest a more gentle or romantic atmosphere

Food & Flowers

Of all the different objects that are featured in still life photographs,
food and flowers must be the most common choice. The reason is
that they're accessible and they offer a rich variety of colours, shapes, textures
and forms, all elements which are central to the success of an image.

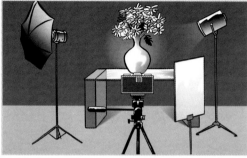

Seeing

This picture began with the vase, which I'd bought at a Spanish potter's workshop. Its shape, and the simple blue and white pattern it featured, appealed to me and I thought it would have potential as an element of a still life set-up.

The set-up for this shot is shown here.

Thinking

I began to consider how I could use it to the best advantage and it occurred to me that one solution could be to restrict the colour content of the entire image to that of the vase itself.

Acting

I had a cloud-effect, fabric background, which was of a similar hue to the vase, and I felt this worked well; by positioning this some distance behind the subject, I ensured that its subtle pattern was slightly out of focus and thus even less intrusive. The vase was placed on a glass shelf - chosen in preference to a solid shelf to avoid the introduction of an intrusive surface - and then I set a flash, fitted with a honeycomb, on the floor and used it to project a small spot of light immediately behind. I lit the set-up from an angle of about 45 degrees with a single diffused flash.

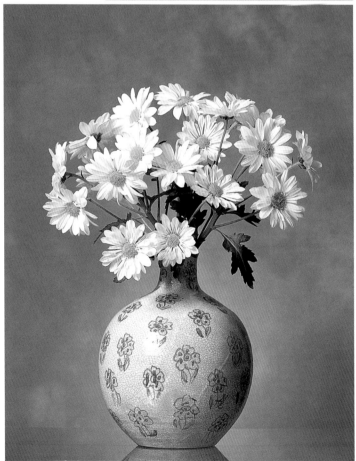

Technical Details
Medium Format SLR Camera with a 105-210 mm zoom lens with Fuji Astia.

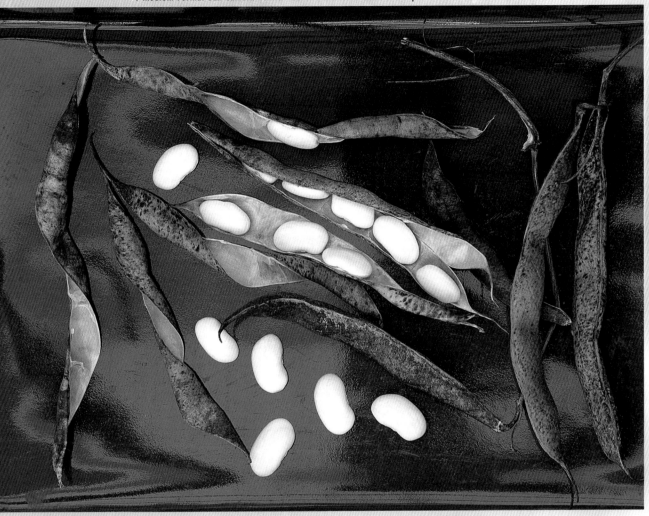

The interesting shapes and the stark whiteness of these haricot beans gave me the inspiration for this picture. In considering a suitable background, I came across this glazed blue dish and liked the combination of this with the brown and white. The lighting was from an overcast sky, which created the attractive highlights on the glaze and provided a soft, even illumination.

Rule of Thumb

As a general rule, it's best to keep to simple arrangements when dealing with flowers and food. The complexity and variety of their shapes, textures and colours, if mixed with too many different elements, can easily result in muddled and confused pictures.

Food & Flowers

Seeing

This photograph was taken in a small factory in Provence, France, where they make a local delicacy called Calissons; a sweetmeat made from honey, dried fruit and almonds. The raw materials for this recipe are, in themselves, quite photogenic, but so too are the implements used and the end product.

Thinking

These items were scattered around the room and workbenches and it was necessary to arrange them in a more orderly way. This bench beside a window seemed ideal and the lighting quality was such that there was no need for reflectors or flash.

Acting

With the camera set-up and roughly framed in front of the window, I began by placing the tray of Calissons in the foreground and then built up the arrangement by positioning the other items one at a time in spots where they created a balanced composition. I used a fairly high viewpoint with a wide-angle lens, which enabled me to look down on the set-up and I used a small aperture to ensure there was enough depth of field to render all the details sharply.

Technical Details
▼ Medium Format SLR Camera with a 105-210 mm zoom lens and Fuji Astia.

The inspiration for this shot resulted from two unrelated incidents; the discovery of an unusually shaped pot followed a week or so later by unearthing of this panel of wood with attractive, blue peeling paint. The two seemed made for each other and it only remained to decide on the pot's contents. The dried grasses were chosen because they did not introduce another bold colour. The set-up was lit by an overcast sky.

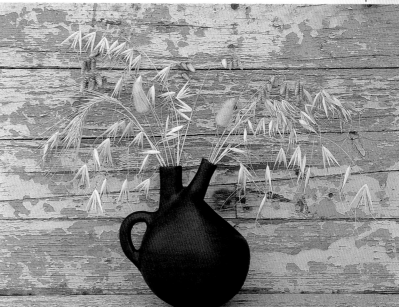

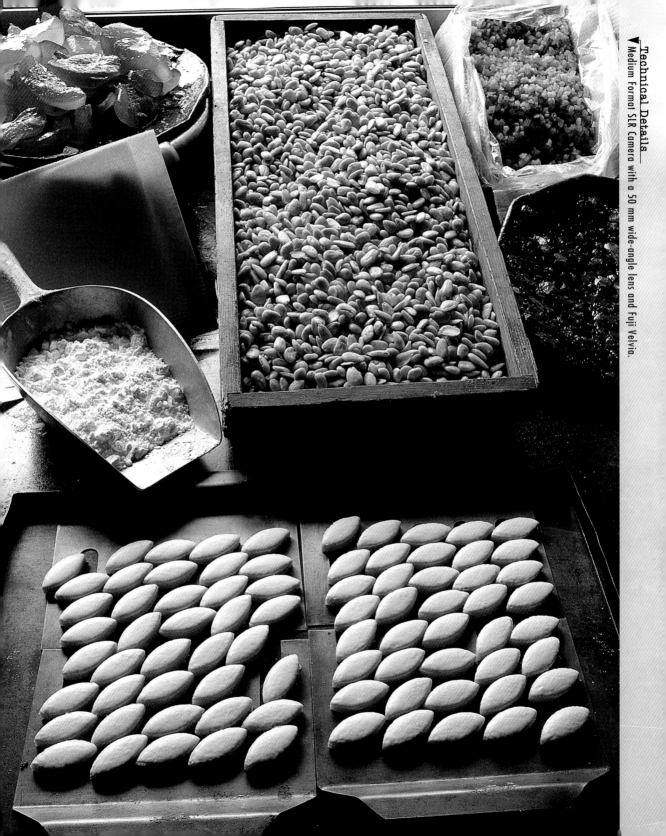

Technical Details
Medium Format SLR Camera with a 50 mm wide-angle lens and Fuji Velvia.

Found Still Lifes

The term 'still life' implies a picture that is arranged by a photographer from items that he or she has selected. But there are other sorts of still life which can be equally satisfying to photograph: those which are found by chance. In the course of everyday life, many still lifes are created by people quite unconsciously, simply as a result of their activities, and they can be just as pleasing to the eye as those which have been painstakingly constructed just for the camera.

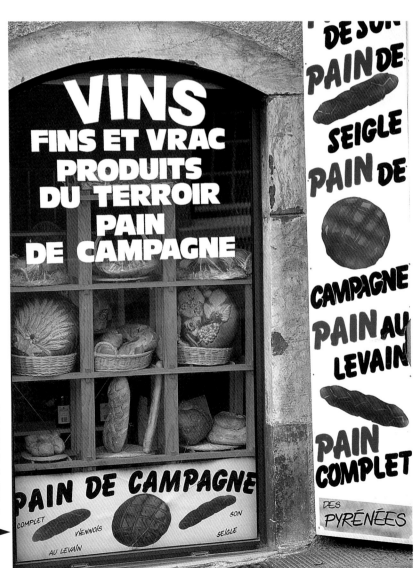

This French boulangerie's window display is, of course, a very deliberately set-up still life but I decided to use the arrangement of bread in the window as an element in a rather bigger picture. By incorporating the lettering, the image is placed in context and interest has been added.

Technical Details
Medium Format SLR Camera with a 55-110 mm zoom lens, an 81A warm-up filter and Fuji Velvia.

Technical Details
▼ 35mm SLR Camera with a 35-70 mm zoom lens,
an 81A warm-up filter and Kodak Ektachrome 64.

Seeing

I found this old wooden cart loaded with vine prunings on a French farm and was immediately attracted by a number of things. I liked the dominant shape created by the old wheel, the texture of the prunings themselves, the restricted colour range and the element of contrast created by the blue arch over the wheel.

Thinking

Having identified the elements of the scene which most appealed to me, it became a relatively simple matter to decide how best to photograph it. The soft light of an overcast sky and the lack of dense shadows meant there were few restrictions on my choice of viewpoint.

Acting

I decided to avoid a full frontal view of the wheel as I thought that a slightly elliptical shape would be less obvious and more interesting. I framed the shot to include all of the vine prunings and a little of the grass at the bottom of the frame, which placed the wheel nicely off-centre.

Rule of Thumb

Deciding on the best viewpoint, and the most effective way of framing a picture, is made much easier if you identify first the key elements of an image and then decide which of these will be the main focus of attention. It's then just a matter of choosing a viewpoint and adjusting the framing so that the other elements of the scene create the most pleasing balance around this feature.

Found Still Lifes

Technical Details
▼ 35mm SLR Camera with a 35-70 mm zoom lens and Fuji Velvia.

Seeing

I had been shooting pictures of the picturesque small harbour of Port Vendres in the Roussillon region of France with my attention fixed mainly on the fishing boats and harbour side houses and I almost missed seeing the possibilities offered by this pile of nets.

Thinking

The scene was so bright and colourful that it was not as easy to find a way of composing the picture as I first thought. The nets were of such a similar, dense colour that it overwhelmed the image and it was not until I discovered this small piece of blue rope that I could begin to see a satisfying picture.

Acting

I found a viewpoint that enabled me to include the rope as well as an area of the nets where there was a marked variation in colour. I framed the shot so that the blue rope was placed along the bottom diagonal corner in a way that also included a small section of a white rope in the opposite corner.

The bold contrast between the yellow melon and purple aubergines couldn't fail to attract the eye in this country market in Sri Lanka. By looking around I managed to find a viewpoint which placed the fruit in the foreground with the pile of vegetables immediately behind. But I had to frame the image more tightly than I would have preferred to exclude some unwanted details.

Technical Details
▼ Medium Format SLR Camera with a 105-210 mm zoom lens and Fuji Velvia.

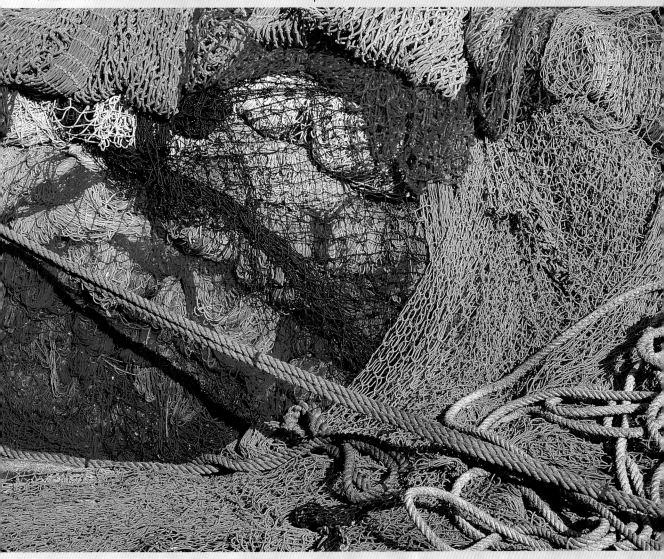

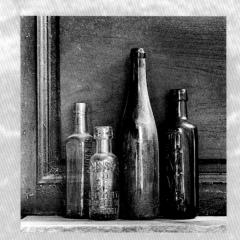

Cameras & Equipment

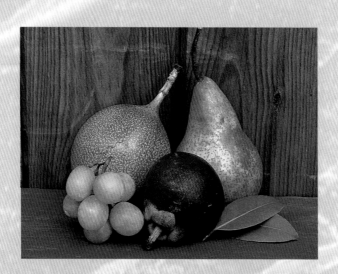

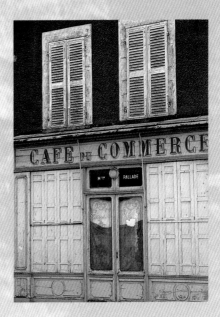

4

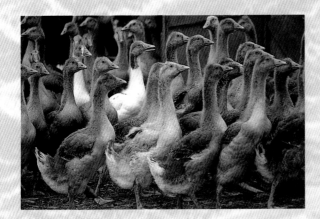

Still-life and close-up photography can encompass a
considerable variety of styles and techniques,
ranging from life-size images of very small subjects photographed outdoors to
elaborate studio set-ups involving lighting, backgrounds and props. In common
with all crafts, having the right tools for the job can make a big difference, both to
the ease of working and to the results achieved. Choosing the right
equipment for your particular needs and understanding how to use it
to its full advantage is the first step.

Choosing a Camera

Technical Details
▼ Medium Format SLR Camera with a
150 mm lens and Kodak Ektachrome 64.

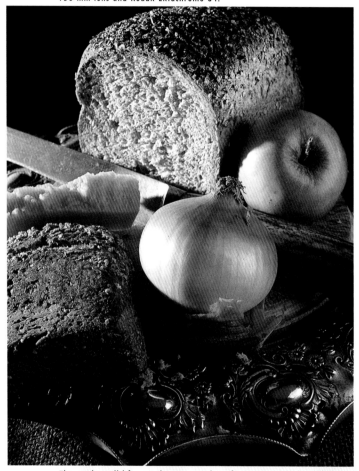

This studio still life was shot on a medium-format camera where the larger image provides a significant improvement in definition over the smaller formats of 35mm and APS. This can be an important factor when transparencies are being produced with publication in mind.

Formats

Image size is the most basic consideration. The image area of a 35mm camera is approximately 24mm x 36mm but with roll film it can be from 45mm x 60mm up to 90mm x 60mm according to camera choice. The degree of enlargement needed to provide, say, an A4 reproduction is much less for a roll film format than for 35mm and gives a potentially higher image quality.

For most photographers the choice is between 35mm, APS and 120 roll film cameras. APS offers a format slightly smaller than 35mm while images larger than 6x9cm call for a view camera of 5x4in or 10x8in format.

Pros & Cons

APS cameras are designed primarily for use with colour negative film and those using this format are faced with a limited choice of film types and accessories. With 35mm SLR cameras your choice is much wider and this format provides the best compromise between image quality, size, weight and cost of equipment. Both accessories and film costs are significantly more expensive when using roll film cameras and the range of lenses and accessories available is more limited than with 35mm equipment.

Technical Details ►
35mm SLR Camera with a 24-85 mm zoom
lens and Kodak Ektachrome 100SW.

View cameras, using sheet film, provide the ultimate in image quality and are particularly suited to still life photography. This is because the camera movements, which are based around the fact that the lens panel and film plane can be tilted in relation to each other, offer a considerable degree of control over depth of field and subject sharpness. The static nature of still life subjects means that the relatively slow operation of a view camera and the lack of a facility to see the image at the moment of exposure are not serious drawbacks.

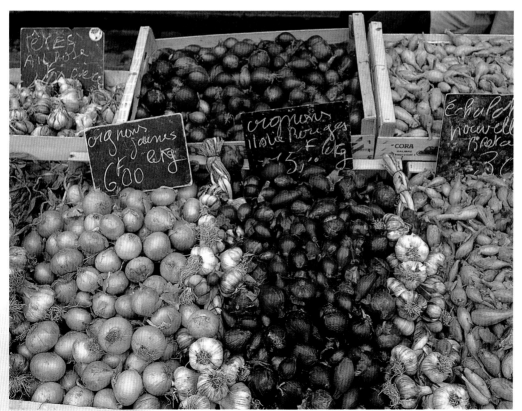

For shots of subjects like this French market stall a 35mm or APS camera is ideal because of the ease of handling, while quality is more than adequate when prints of around 7x5ins are required.

Camera Types

There are two basic choices offered with Roll Film, 35mm and APS cameras; the Viewfinder or Rangefinder Camera and the Single Lens Reflex (SLR). The latter is best for close-up photography because of the greater accuracy of viewing and focussing.

Technical Details
▼ Medium Format SLR Camera with a 55-110 mm zoom lens and Fuji Velvia.

The viewing system of the SLR makes it more accurate than a viewfinder camera when focused at close distances and, unlike the latter, it's also possible to see the effect of focusing and depth of field.

Pros & Cons

The SLR allows you to view through the taking lens and to see the actual image which will be recorded on film, but the Viewfinder Camera uses a separate optical system. This can be a major disadvantage particularly when shooting close-ups, as an optical viewfinder becomes increasingly inaccurate as the camera is moved closer to the subject. In addition, the whole image appears in focus when seen through a Viewfinder Camera but the effect of focusing can be seen directly in the viewing screen of the SLR making it quick and accurate. Some SLRs feature a stop down facility to allow you to see the effect of the set aperture too, which enables you to judge accurately the depth of field.

Technical Details
▼ 5x4 inch View Camera with a 150 mm lens and Fuji Astia.

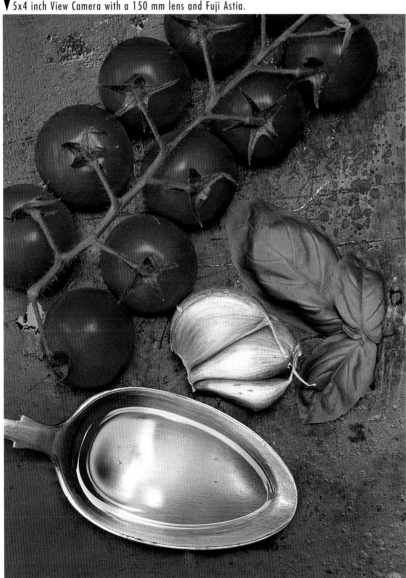

Generally, facilities like autofocus and exposure control are more accurate and convenient with SLR cameras and you can see the effect of filters and attachments. SLR cameras have a much wider range of accessories and lenses available to them and are more suited to subjects like wild life when very long-focus lenses are needed.

Viewfinder cameras, such as the Leica or Mamiya 7, tend to be lighter and quieter than their equivalent SLRs but they are not ideally suited to very close-up photography because of the limitations of the viewing system.

The relative sizes of the different camera formats are shown here.

For still lifes like this, the large image size of a view camera will provide optimum quality and definition while the ability to tilt the lens and film planes provides a very useful additional means of controlling depth of field.

Choosing Lenses

Technical Details

▼ 35mm SLR Camera with a 90 mm macro lens and Fuji Velvia.

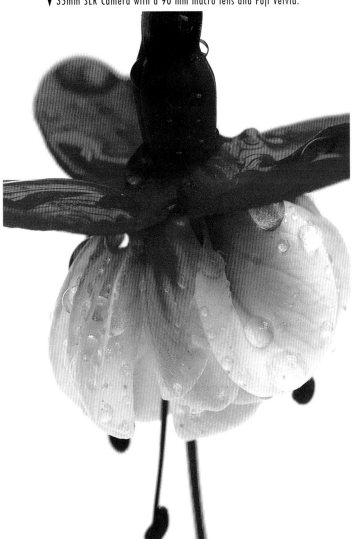

A standard lens is one that takes in a field of view of about **45 degrees** and which has a focal length equivalent to the diagonal measurement of the film format. This equates to 50mm with a 35mm camera and 80mm with a 6 x 6cm camera.

Lenses with a shorter focal length have a wider field of view and those with a longer focal length produce a narrower field of view. **Zoom lenses** provide a wide range of focal lengths within a single optic, taking up less space and doing away with the requirement for several fixed lenses.

A macro lens allows you to produce a life-size image of a subject on the film without the need for accessories like extension tubes or **bellows units**. Such lenses are also designed to give their optimum definition when focused at close distances.

This diagram shows the relative fields of view produced by lenses with a range of focal lengths when used with the 35mm format.

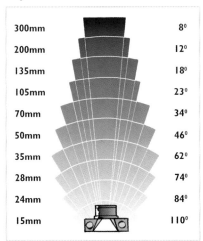

Focal length	Field of view
300mm	8⁰
200mm	12⁰
135mm	18⁰
105mm	23⁰
70mm	34⁰
50mm	46⁰
35mm	62⁰
28mm	74⁰
24mm	84⁰
15mm	110⁰

Technical Details

▼ 35mm SLR camera with a 70-210 mm lens, an 81A warm-up filter and Fuji Velvia.

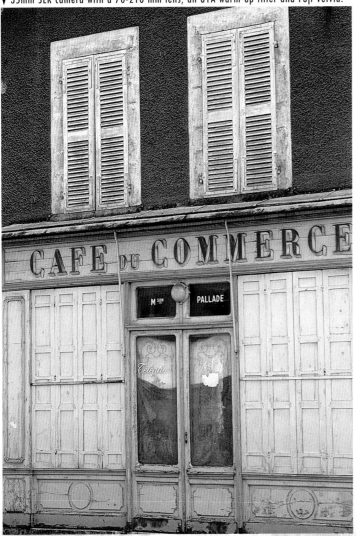

Pros & Cons

Many ordinary zooms have a maximum aperture of f5.6 or smaller. This can be quite restricting when fast shutter speeds are needed in low light levels and a fixed focal-length lens with a wider maximum aperture of f2.8 or f4 can sometimes be a better choice. Zoom lenses are available for most 35mm SLR cameras over a wide range of focal lengths but it's important to appreciate that image quality will be lower with lenses which are designed to cover more than about a three to one ratio, for example 28-85 mm or 70mm-210mm.

Special Lenses

A lens of more than 300mm will seldom be necessary for most still life and close-up photography but one between 400mm-600mm is often necessary to obtain close-up images of subjects such as wild animals and birds.

Extenders can allow you to increase the focal length of an existing lens; a x 1.4 extender will turn a 200mm lens into a 280mm and a x 2 extender will make it a 400mm. There will, however, be some loss of sharpness with all but the most expensive optics and a reduction in maximum aperture of one and two stops respectively.

A long-focus lens can be used to produce a close-up image of a subject from a distant viewpoint.

Camera Accessories

There is a wide range of accessories that can be used to control the image and increase the camera's capability. Extension tubes, bellows units and dioptre lenses will all allow the lens to be focused at a closer distance than it's designed for.

▼ 35mm SLR Camera with a 90 mm macro lens, an extension tube and Fuji Velvia.

Technique

For still life photography, a soft-focus filter can be effective in some circumstances to help create a more romantic mood.

A selection of filters will help to extend the degree of control over the tonal range of a black and white image and a square filter system, as produced by manufacturers such as Cokin or HiTech, will give you the most convenient and practical option. These allow the same filters to be used with all your lenses regardless of the size of the lens mounts, as each can be fitted with an adaptor upon which the filter holder itself can be easily slipped on and off.

A polarising filter is extremely useful for reducing the brightness of reflections from non-metallic surfaces, such as foliage, and it will also deepen and richen the colour of a blue sky to allow a greater contrast to be created against white clouds.

Polarisers are available in either linear or circular form. The former can interfere with some auto focusing and exposure systems; your camera's instruction book should advise, but if in doubt use a circular polariser.

I used a macro lens in conjunction with an extension tube to produce this bigger than life-size image of a section of a leaf.

This diagram shows an extension tube fitted between the camera body and lens.

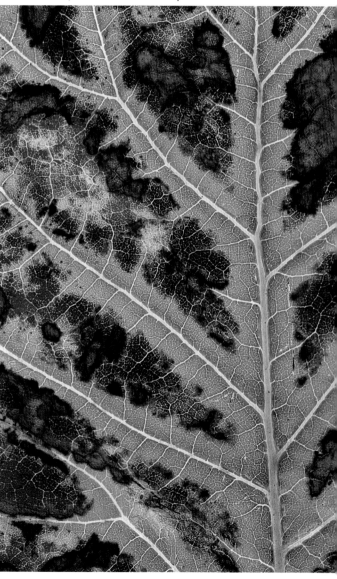

Technical Details
▼ Medium Format SLR Camera, 105-210 mm
zoom lens and Fuji Velvia.

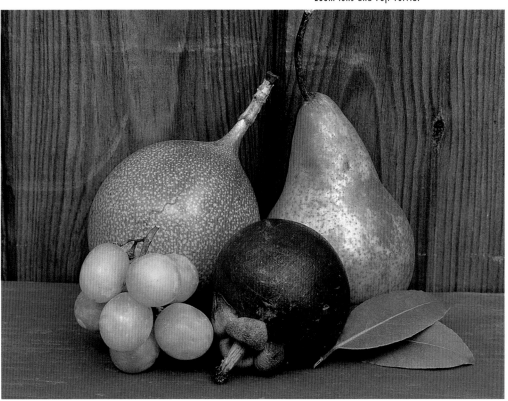

I shot this still life of fruit outdoors on a dull day. Because I
needed to use a small aperture for good depth of field and
a slow film for maximum definition I had to use a shutter
speed of 1/2 sec, which would not have been possible
without a tripod.

Technique

For still life and close-up photography in particular, a tripod
should be considered obligatory, as it enables you to
aim, frame and focus the camera on your subject in the
knowledge that it will remain accurately positioned. This
allows you to concentrate more on matters like
composition and lighting.

Lighting Equipment

Although many cameras now feature built in flash a separate flash gun can still be a very useful accessory. It will be much more powerful than the built in variety and it can be used off camera, fitted with a diffuser and used to bounce light from a ceiling. It's best to buy the most powerful which size and budget will allow.

A ring flash can be especially useful for close-up photography as it can be very difficult to illuminate a subject with a conventional flash gun when it is very close to the camera. With a ring flash the flash tube is circular and fits around the front of the lens, creating a shadowless light.

For still life photography, a modest range of studio lighting equipment will greatly increase your scope. Although a small flash gun is a useful accessory in most circumstances it has limited use in this field as, unlike purpose-built studio lighting, it is not possible to judge the lighting effect before taking your photographs.

It's possible to buy, at relatively modest cost, two or three photoflood or tungsten halogen lights with a variety of reflectors and stands, which will allow you to create a wide range of effects. In addition to the normal dish reflectors you will also need a means of creating a diffused light and a device for restricting light spill, such as a snoot, spotlight or honeycomb.

An umbrella reflector, or soft box is ideal but you can also make a simple diffusing screen using a wooden frame covered with tracing paper, frosted acetate, nylon mesh or garden fleece. A couple of white fill-in reflectors are also invaluable; large sheets of inch-thick polystyrene, available from DIY stores, are ideal but you will also find a variety of purpose-built models, such as the collapsible Lastolite, in most photo stores.

Technical Details

▼ Medium Format SLR Camera, 105-210 mm zoom lens and Fuji Velvia.

For this shot of a beer glass I used a flash fitted with a honeycomb to throw a pool of light onto the background, with another bounced off a reflector close to the set-up to create some reflections in the glass and to reduce the contrast.

Technical Details

▼ Medium Format SLR Camera, 105-210 mm zoom lens and Fuji Velvia.

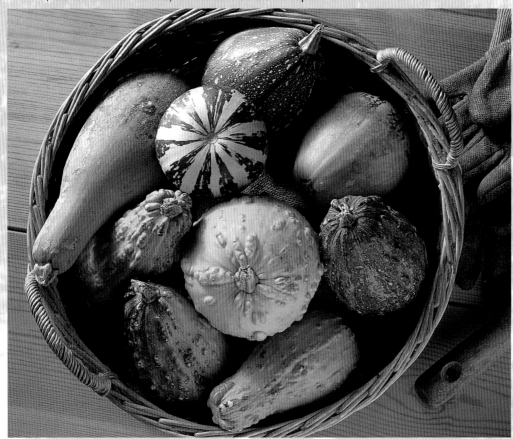

I used a single, lightly-diffused flash from slightly above the level of this set-up, with a white reflector on the opposite side to bounce some light back into the shadows.

The choice of studio flash equipment is very wide but the mono-block system is ideal for the small studio or home use. These have the flash generator, flash tubes and a modelling light built into a single small unit. A synchronising lead or remote trigger to the camera connects one and the others are fired simultaneously by a slave cell.

You can use the camera's built in metering system when using tungsten lighting but for flash lighting you will need to buy a special, separate flash meter. It's also important to appreciate that flash equipment can limit your choice of apertures and the corresponding depth of field when shooting still life subjects as the aperture you use is partly determined by the power of the flash.

For studio work you will also need to consider backgrounds. For larger set-ups nine feet wide rolls of cartridge paper are available from photo stores in a wide range of colours. They can be suspended from wall brackets, sprung poles or tripod stands and draped onto the floor or a still life bench in a seamless curve. Alternatively you can buy painted or textured fabric backdrops from companies such as Lastolite.

For smaller arrangements you can create a considerable variety of effects by simply painting sheets of MDF or hardboard. Most good DIY stores now stock the materials to create a wide range of paint effects and textures, such as scumble and rag rolling.

Apertures & Shutter Speeds

The aperture is the device which controls the brightness of the image falling upon the film and is indicated by f stop numbers f2, f2.8, f4, f5.6, f8, f11, f16, f22, f32. Each step down, from f2.8 to f4 for example, reduces the amount of light reaching the film by 50 per cent and each step up, from f8 to f5.6 for instance, doubles the brightness of the image.

The shutter speed settings control the length of times for which the image is allowed to play on the film and, in conjunction with the aperture, control the exposure and quality of the image.

The effect becomes more pronounced as the focal length of the lens increases and as the focusing distance decreases. So with, say, a 200mm lens focused at one metre and an aperture of f2.8 the range of sharp focus will extend only a very short distance in front and behind the subject.

Technique

Shallow depth of field can be very useful, especially when taking close-up photographs of subjects like flowers in situ, as it can be used to reduce background details to a soft homogeneous blur making the subject stand out in sharp relief.

The depth of field increases when a smaller aperture is used and when using a short focal length, or wide-angle lens. In this way a 24mm lens focused at, say, one metre at an aperture of f22 would provide a much wider range of sharp focus than the previous example. A camera with a depth of field preview button will allow you to judge the depth of field in the viewfinder.

Rule of Thumb

Choice of aperture also influences the depth of field, which is the distance in front of and beyond the point at which the lens is focused. At wide apertures, like f2.8, the depth of field is quite limited making closer and more distant details appear distinctly out of focus.

The choice of shutter speed determines the degree of sharpness with which a moving subject will be recorded. With a fast-moving subject, like an animal running or a bird flying, a shutter speed of 1/1000 sec or faster will be needed to obtain a sharp image.

Technique

When a subject is travelling across the camera's view, panning the camera to keep pace with the movement will often make it possible to obtain a sharp image at slower speeds. This technique can be used to create the effect where the moving subject is sharp but the background has movement blur and this can considerably heighten the effect of speed and movement.

Rule of Thumb

The choice of shutter speed can also affect the image sharpness of a static subject when the camera is handheld, as even slight camera shake can easily cause the image to be blurred. The effect is more pronounced with long focus lenses and when shooting close ups. The safest minimum shutter speed should be considered as a reciprocal of the focal length of the lens being used, for example 1/200 sec with a 200 mm lens.

▼ 35mm SLR Camera with a 70-200 mm zoom lens, an extension tube and Fuji Velvia.

I used a long-focus lens combined with a wide aperture for this shot of wine glasses in order to create a very shallow depth of field and to throw the background details out of focus.

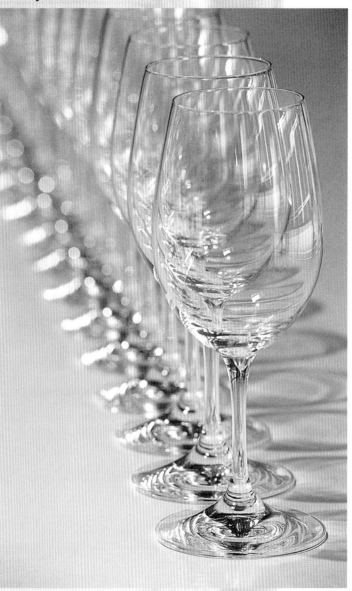

I used a 24mm wide-angle lens together with an extension tube for this shot of a computer component. I used a small aperture to obtain maximum depth of field and used the lens' tilting facility to increase it further.

▲ Technical Details
35mm SLR Camera, 24 mm wide-angle tilt shift lens, an extension tube and Fuji Velvia.

Understanding Exposure

Modern cameras with automatic exposure systems have made some aspects of achieving good quality images much easier but no system is infallible and an understanding of how exposure meters work will help to ensure a higher success rate.

An **exposure meter**, whether it's a built-in TTL meter or a separate hand meter, works on the principle that the subject it is aimed at is a mid tone, known as an 18 per cent grey. In practice, of course, the subject is invariably a mixture of tones and colours but the assumption is still that, if mixed together like so many pots of different-coloured paints, the resulting blend would still be the same 18 per cent grey tone.

With most subjects the reading taken from the whole of the subject will produce a satisfactory exposure. But if there are aspects of a subject which are abnormal, where for example it contains large areas of very light or dark tones, the reading needs to be modified.

An **exposure reading** from a still life of white crockery on a white table cloth, for instance, would, if uncorrected, record it as grey on film. In the same way a reading taken from a very dark subject would result in the image being too light.

The exposure needs to be decreased when the subject is essentially dark in tone or when there are large areas of shadow close to the camera. With abnormal subjects it is often possible to take a close up or **spot reading** from an area which is of normal, average tone.

Technique

Many cameras allow you to take a spot reading from a small area of a scene as well as an average reading and this can be useful for **calculating** the **exposure** with subjects of an abnormal tonal range or of high contrast. Switching between the average and spot reading modes is also a good way of checking if you are concerned about a potential exposure error. If there is a difference of more than about half a stop you need to consider the scene more carefully to decide if a degree of exposure compensation is required.

Technical Details
▼ 35mm SLR Camera, 90 mm macro lens and Fuji Velvia.

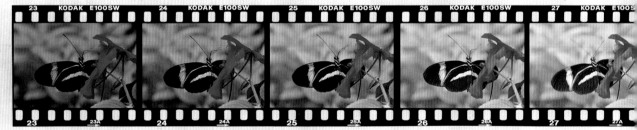

These pictures of a butterfly show the effect of bracketing exposures. The central image received the exposure indicated by the meter while the two darker frames had 1/3 and 2/3 of a stop less and the two lighter frames had 1/3 and 2/3 of a stop more.

Technical Details
▼ Medium Format SLR Camera, 105-210 mm zoom lens and Fuji Velvia.

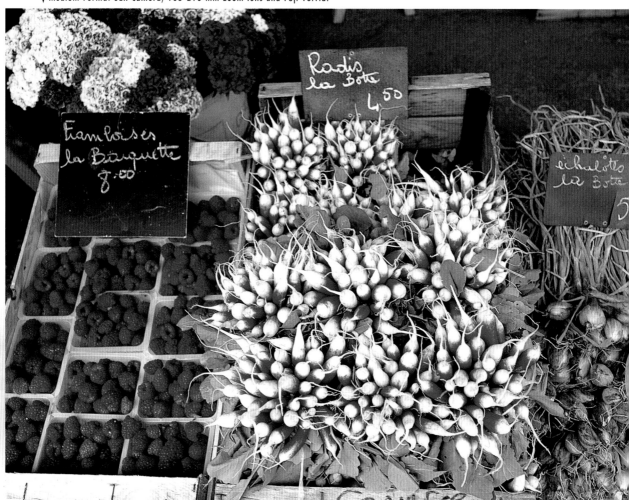

This subject had a normal range of tones and colours and is of average contrast, consequently the exposure indicated by TTL metering using centre-weighted or matrix metering modes did not need to be compensated.

Understanding Exposure

Negative films have a latitude of one stop or more each way and small exposure errors will not be important. If you use transparency film, however, even a slight variation will make a significant difference to the image quality and, where possible, it's best to bracket exposures giving a third or half a stop more and less than that indicated, even with normal subjects.

Technique

Clip testing is an effective way of overcoming this problem. For this technique you need to establish your exposure and shoot a complete roll at the same setting, assuming the lighting conditions remain the same. You need to allow two frames at the end of the roll, in the case of roll film, or shoot three frames at the beginning of a 35mm film, which you must ask the processing laboratory to cut off and process normally. The exposure can then be judged and the processing time of the remainder of the film adjusted to make the balance of the transparencies lighter or darker if necessary. Increasing the effective speed of the film and making the transparency lighter - known as pushing - is more effective than the opposite method - known as pulling - which reduces the film speed, and makes the image darker. For this reason it is best to set your exposure slightly less than calculated if in any doubt.

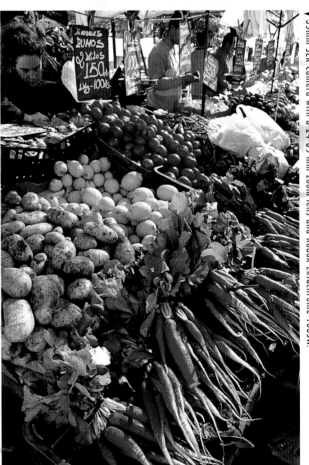

Technical Details
35mm SLR Camera with a 24-85 mm zoom lens and Kodak Ektachrome 100SW.

I gave half a stop more than the meter suggested to compensate for the back lighting in this Spanish market scene. The bright highlights suggested less exposure than was actually needed, which would have resulted in the image being underexposed and too dark.

Exposure for Close-Ups

When the lens is extended from the film plane by the means of bellows or extension tubes, for instance, in order to focus at closer distances, an increase in exposure is required. With cameras such as SLRs which have "through-the-lens" metering the necessary compensation will be made automatically. But when a separate exposure meter is used, as with a View Camera for instance, or when using a Flash Meter, you need to calculate the additional exposure required according to the following formula: Divide the square of amount the lens is extended by the square of its focal length and the result is by how much the exposure must be increased. ie. If a 50mm lens is extended to 100mm then 10,000 divided by 2,500 = 4. Thus, four times the exposure (or two stops) extra must be given.

Technique

Exposure compensation can also be used to alter the quality and effect of an image, especially with transparency film. When a lighter or darker image is required this can be adjusted at the printing stage when shooting on negative film but with transparency film it must be done at the time the film is exposed.

Technical Details
▼ 35mm SLR Camera, 20-35 mm zoom lens and Fuji Velvia.

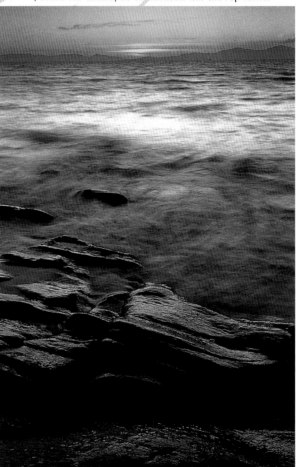

For this shot, taken in Scotland's Mull of Kintyre, I gave half a stop less than the meter indicated in order to produce a slightly darker transparency and to create a low-key, moody image.

Choosing Film

There is a huge variety of film types and speeds from which to choose and although, to a degree, it is dependent on personal taste there are some basic considerations to be made. Unless you wish to achieve special effects through the use of film grain it is generally best to choose a slow, fine-grained film for still life and close-up photography, assuming the subject and lighting conditions will permit.

The choice between colour negative film and transparency film depends partly upon the intended use of the photographs. For book and magazine reproduction transparency film is universally preferred and most photo libraries also demand transparencies. And, of course, transparency film is necessary for slide presentations.

But for personal use, and when colour prints are the main requirement, colour negative film can be a better choice since it has greater exposure latitude and is capable of producing high quality prints at a lower cost.

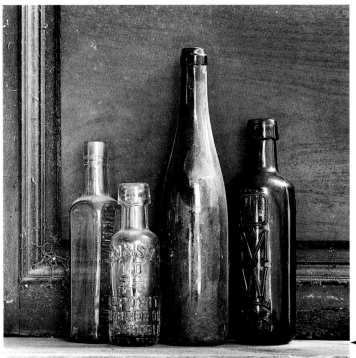

Black and White Films

Although colour film is very widely used in still life and close-up photography there are many situations where striking black and white images can be produced and many photographers prefer this medium for personal work and fine-art photography.

In addition to conventional black-and-white films like Ilford's FP4 and Kodak's Tri X there are also films such as Ilford's XP2 Super and Kodak's T400 CN which use colour negative technology and can be processed in the same way at one-hour photo labs to produce a monochrome print.

For special effects, fast films such as Kodak's 2475 recording film can produce a very pronounced, almost crystalline, grain structure, which can look very effective when used with certain subjects. Infrared film, both black and white and colour, can also be used to produce images with a very unusual quality.

Agfa's Scala is a process-paid black and white transparency film with a particularly pleasing silvery, translucent quality. It too is ideal for those who don't wish to process their own films and it provides the opportunity to show the images in a slide projector as well as making it possible to produce reversal prints. It can be used to create interesting tinted monochrome effects using printing materials such as Ilfochrome.

I used Ilford's XP2 black and white film for this still life of bottles, which was shot outdoors using daylight.

◄ **Technical Details**
Medium Format SLR Camera with a 150 mm lens and Ilford XP2.

Technical Details
▼ 35mm SLR Camera with a 28-70 mm zoom lens and Fuji Velvia.

I used daylight-type transparency film for this shot of olive oil casks in a room that was lit partially by artificial light. This has resulted in a noticeably warm colour cast.

I used a fast film for this shot of geese as I needed to use a fast shutter speed and the light level was too low for the use of a slower, more fine-grained film.

Technical Details
35mm SLR Camera with a 70-210 mm ▼ zoom lens and Kodak Ektachrome 200.

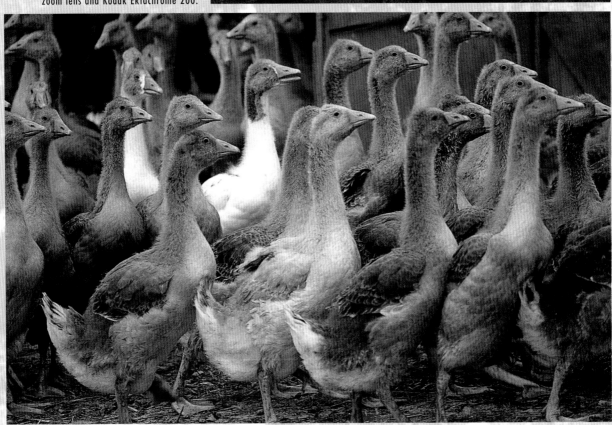

Using Filters

Even in the best conditions, filters are often necessary, especially when shooting on transparency film. It's important to appreciate that colour transparency film is manufactured to give correct colour balance only in conditions where the light source is of a specific colour temperature. Daylight colour film is balanced to give accurate colours at around 5,600 degrees Kelvin but daylight can vary from only about 3,500 degrees K close to sundown to over 20,000 degrees K in open shade when there is a blue sky.

The effect of an imbalance between the colour temperature of the light source and that for which the film is balanced can be very noticeable. The blue tint, for example when shooting in open shade can be quite marked and in these situations a warm-up filter, such as an 81A or B is needed. In late afternoon the sunlight can be excessively warm for some subjects and then a blue-tinted filter such as an 82A or B is needed.

A polarising filter can be very useful for increasing the colour saturation of details such as foliage and for making the sky or sea a richer colour. It is equally effective when used with colour print film, whereas the qualities created by a colour balancing filters can easily be achieved when making colour prints from negatives.

A polariser can also help to subdue excessively bright highlights - such as the sparkle on rippled water - when shooting into the light. Polarisers need between one and a half and two stops extra exposure but this will be automatically allowed for when using TTL metering.

Neutral graduated filters are a very effective means of making the sky darker and revealing richer tones and colours. They can also reduce the contrast between a bright sky and a darker foreground giving improved tones and colours in both.

Technical Details
▼Medium Format SLR Camera with a 105-210mm zoom lens, polarising and 81A warm-up filters with Fuji Velvia.

For this close-up of newly-sawn logs I used an 81A warm-up filter to accentuate the rich colour of the wood and a polarising filter to make the sky a darker and more saturated hue.

This photograph of a canyon in Morocco was taken in the early morning and it shows just how much difference there is between the colour temperature of early morning sunlight, reflected from the cliff face, and that directed from the blue sky. Here it's resulted in the grey rocks having a distinctly blue cast.

Careful finishing and presentation is
essential if the full impact of a photograph is to be realised and even the finest
work will be diminished if some care is not taken at this stage.

Storing your Photographs

Card mounts are the most suitable way of storing and presenting colour transparencies. They can be printed with your name and address together with caption information using labels. Added protection can be given by the use of individual clear plastic sleeves, which slip over the mount.

Technique

When colour transparencies are to be used as part of a portfolio, a more stylish and polished presentation can be created by using large black cut out mounts which hold up to 20 or more slides - depending on format - in individual black mounts. These can be slipped into a protective plastic sleeve with a frosted back for easy viewing.

Technique

Be quite ruthless about eliminating any rather similar or repetitive images. Even for personal use the impact of your photographs will be greatly increased if only the very best of each situation is included and a conscious effort is made to vary the nature of the pictures.

Technique

For purely personal use, many photographers use flip-over albums as a means of showing their prints. This method is, at best, simply a convenient way of storing prints and does nothing to enhance their presentation. It can be far more pleasing and effective to show a collection of images as a series of prints mounted on the pages of an album, choosing one which is large enough to allow six or more photos to be seen together on a spread.

For portfolio and exhibition prints, and those where archival permanency is required, it's best to simply hold the print in place on the mounting board with acid-free tape across the corners and then complete the presentation by placing a bevel cut-out mount on top to frame it. You can cut these yourself to size using a craft knife, or there are special tools available, but they can also be bought ready-made in the most popular sizes from art stores.

Strong images can be very effective for display in the home or office and a nicely-mounted group of prints, in simple black or metallic frames, can create a very effective focal point for the decor of a room.

Rule of Thumb

The simplest way of storing mounted transparencies is in viewpacks: large plastic sleeves with individual pockets which can hold up to 24x35mm slides, or 15x120 transparencies. These can be fitted with bars for suspension in a filing-cabinet drawer and can be quickly and easily lifted out for viewing. For slide projection however it is far safer to use plastic mounts, preferably with glass covers, to avoid the risk of popping and jamming inside the projector.

Technique

Even the finest print will be improved by good presentation and mounting it flat onto a heavy weight card is the first stage. **Dry mounting** ensures a perfectly flat, mounted print; this involves placing a sheet of **adhesive tissue** between the print and its mount and applying heat and pressure, ideally with a dry-mounting press though a domestic iron can also be used.

The different effects, which can be created by changing the way a photographic print is mounted and presented, are shown here.

Technique

Where photographs are taken for purely pictorial purposes, building up a body of work is one of the most **stimulating** and challenging projects for a photographer. The formation of a **portfolio** or collection of images with a central theme is an excellent way of doing this.

Technique

There are a number of ways of **selling your work** and finding a potential outlet for your work in print. Good still life and close-up photographs are in constant demand by publishers of **magazines**, as well as from **book publishers** dealing with subjects like nature, gardening, food and home making, of which there are a large number. In fact there is a ready market for most subjects if the photographs are well executed.

Technique

Spend some time **researching** the market in your local library, or at a friendly newsagents, and see just how the photographs are used in such publications and what type of image they seem to prefer. Make a note of some names, like the editor, features editor and picture editor.

The are some useful **reference books** available like the Freelance Writers' and Artists' Handbook and the Freelance Photographers' Market Handbook, but these are, at best, only a general guide to potential users and it is vital to study each publication before you consider making a submission.

Books and magazines represent only a small proportion of the **publications** that use still life and close-up images. Other **potential outlets** include calendars, greetings cards, packaging and advertising.

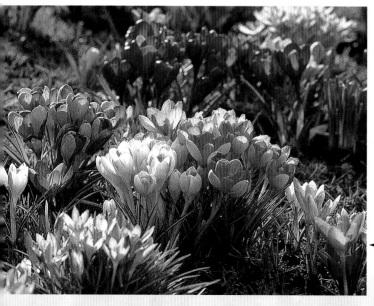

This picture of spring crocuses, taken on a village green in Yorkshire, UK, was used as a greetings card by a specialist publisher and is typical of the type of close-up image used for such purposes. Gardening magazines and books are also potential users.

◄ **Technical Details**
Medium Format SLR Camera with a 105-210mm zoom lens, an extension tube and Fuji Velvia.

Technique

As a general rule, you will be expected to submit several hundred **transparencies** initially, and will probably be obliged to allow those selected to be retained for a minimum period of three years. Your selection should be ruthlessly **edited** as only top-quality images will be considered and you should make sure that you send only the very best pictures from each situation.

Although a good **photo library** can produce a substantial income in time from a good collection of photographs it will take as much as a year before you can expect any returns and most libraries prefer photographers who make **contributions** on a fairly regular basis.

A portfolio album is a very effective and professional way of presenting large colour or black-and-white prints and offers a high degree of protection.

Glossary

Aperture Priority

An auto exposure setting in which the user selects the aperture and the camera's exposure system sets the appropriate shutter speed.

APO lens

A highly corrected lens which is designed to give optimum definition at wide apertures and is most often available in the better quality long-focus lenses.

Ariel Perspective

The tendency of distant objects to appear bluer and lighter than close details, enhancing the impression of depth and distance in an image.

Auto Bracketing

A facility available on many cameras which allows three or more exposures to be taken automatically in quick succession, giving both more and less than the calculated exposure. Usually adjustable in increments of one third, half or one stop settings and especially useful when shooting colour transparency film.

Bellows Unit

An adjustable device which allows the lens to be extended from the camera body to focus at very close distances.

Black Reflector

A panel with a matt black surface used to prevent light being reflected back into shadow areas in order to create a dramatic effect.

Cable Release

A flexible device that attaches to the camera's shutter release mechanism and which allows the shutter to be fired without touching the camera.

Close-up Lens

This is a weak positive lens placed in front of a prime lens to enable it to be focused at a closer distance than it is designed for. They can be obtained in various strengths and do not require an increase in exposure, as in the case of extension tubes and bellows units.

Colour Cast

A variation in a colour photograph from the true colour of a subject, which is caused by the light source having a different colour temperature to that for which the film is balanced.

Colour Temperature

A means of expressing the specific colour quality of a light source in degrees Kelvin. Daylight colour film is balanced to give accurate colours at around 5,600 degrees Kelvin but daylight can vary from only 3,500 degrees K close to sundown to over 20,000 degrees K in open shade when there is a blue sky.

Cross Processing

The technique of processing colour transparency film in colour negative chemistry, and vice versa, to obtain unusual effects.

Data Back

A camera attachment that allows information like the time and date to be printed on the film alongside, or within the images.

Dedicated Flash

A flash gun which connects to the camera's metering system and controls the power of the flash to produce a correct exposure. Will also work when the flash is bounced or diffused.

Depth of Field

The distance in front and behind the point at which a lens is focused which will be rendered acceptably sharp. It increases when the aperture is made smaller and extends about two thirds behind the point of focus and one third in front. The depth of field becomes smaller when the lens is focused at close distances. A scale indicating depth of field for each aperture is marked on most lens mounts and it can also be judged visually on SLR camera cameras that have a depth of field preview button.

Double Extension

The term used when the lens is extended beyond the film plane to twice its focal length by the means of Macro Focusing, Extension Tubes or a Bellows Unit to give a life-size image on the film. This requires four times the exposure indicated when the lens is focused at infinity, but will be automatically allowed for when using TTL (through-the-lens) metering.

DX Coding

A system whereby a 35mm camera reads the film speed from a bar code printed on the cassette and sets it automatically.

Evaluative Metering

An exposure meter setting in which brightness levels are measured from various segments of the image and the results used to compute an average. It's designed to reduce the risk of under or overexposing subjects with an abnormal tonal range.

Exposure Compensation

A setting which can be used to give less or more exposure when using the camera's auto-exposure system for subjects which have an abnormal tonal range. Usually adjustable in one third of a stop increments.

Exposure Latitude

The ability of a film to produce an acceptable image when an incorrect exposure is given. Negative films have significantly greater exposure latitude than transparency films.

Extension Tubes

Tubes of varying lengths, which can be fitted between the camera body and lens used to allow it to focus at close distances. Usually available in sets of three different widths.

Fill In Flash

A camera setting, for use with dedicated flash guns, which controls the light output from a flash unit and allows it to be balanced with the subject's ambient lighting when it is too contrasty or there are deep shadows.

Filter Factor

The amount by which the exposure must be increased to allow for the use of a filter. A x 2 filter requires an increase of one stop and a x 4 filter requires a two-stop exposure increase.

Flash Meter

An exposure meter that is designed to measure the light produced during the very brief burst from a flash unit.

Grey Card

A piece of card which is tinted to reflect 18 per cent of the light falling upon it. It is the standard tone to with which exposure meters are calibrated and can be used for substitute exposure readings when the subject is very light or dark in tone.

Honeycomb

A grill-like device, which fits over the front of a light reflector to restrict its beam and limit spill.

Hyperfocal Distance

The closest distance at which details will be rendered sharp when the lens is focused on infinity. By focusing on the Hyperfocal distance you can make maximum use of the depth of field at a given aperture.

Incident Light Reading

A method, involving the use of a hand meter, of measuring the light falling upon a subject instead of that which is reflected from it.

ISO Rating

The standard by which film speed is measured. Most films fall within the range of ISO 25 to ISO 3200. A film with double the ISO rating needs one stop less exposure and a film with half the ISO rating needs one stop more exposure. The rating is subdivided into one third of a stop settings ie. 50, 64, 80,100.

Macro Lens

A lens which is designed to focus at close distances to produce up to a life-size image of a subject and is corrected to give its best performance at this range.

Matrix metering

See Evaluative metering

Mirror Lock

A device which allows the mirror of an SLR camera to be flipped up before the exposure is made to reduce vibration and avoid loss of sharpness when shooting close ups or using a long-focus lens.

Polarising Filter

A neutral grey filter which can reduce the brightness of reflections in non-metallic surfaces such as water, foliage and blue sky.

Programmed Exposure

An auto-exposure setting in which the camera's metering system sets both aperture and shutter speed according to the subject matter and lighting conditions. Usually offering choices like landscape, close up, portrait, action etc.

Pulling

A means of lowering the stated speed of a film by reducing the development times.

Pushing

A means of increasing the stated speed of a film by increasing the development times.

Reciprocity Failure

The effect when very long exposures are given. Some films become effectively slower when exposures of more than one second are given and doubling the length of the exposure does not have as much effect as opening up the aperture by one stop.

Reversing Ring

A device which enables an ordinary lens to be mounted back to front on the camera, which allows it to be focused at very close distances.

Shutter priority

A mode on auto-exposure cameras that allows the photographer to set the shutter speed while the camera's metering system selects the appropriate aperture.

Snoot

A conical device, which fits over the front of a light reflector to restrict its beam and limit spill.

Spot Light

A light source fitted with a lens, which enables a precisely focused beam of light to be projected.

Spot Metering

A means of measuring the exposure from a small and precise area of the image which is often an option with SLR cameras. It is useful when calculating the exposure from high contrast subjects or those with an abnormal tonal range.

Substitute Reading

An exposure reading taken from an object of average tone which is illuminated in the same way as the subject. This is a useful way of calculating the exposure for a subject which is much lighter or darker than average.